Images of Modern America

SPRINGFIELD

CURTIS MANN
AND MELINDA GARVERT

ARCADIA
PUBLISHING

Copyright © 2017 by Curtis Mann and Melinda Garvert
ISBN 978-1-4671-2423-2

Published by Arcadia Publishing
Charleston, South Carolina

Printed in the United States of America

Library of Congress Control Number: 2016939021

For all general information, please contact Arcadia Publishing:
Telephone 843-853-2070
Fax 843-853-0044
E-mail sales@arcadiapublishing.com
For customer service and orders:
Toll-Free 1-888-313-2665

Visit us on the Internet at www.arcadiapublishing.com

Images of Modern America

SPRINGFIELD

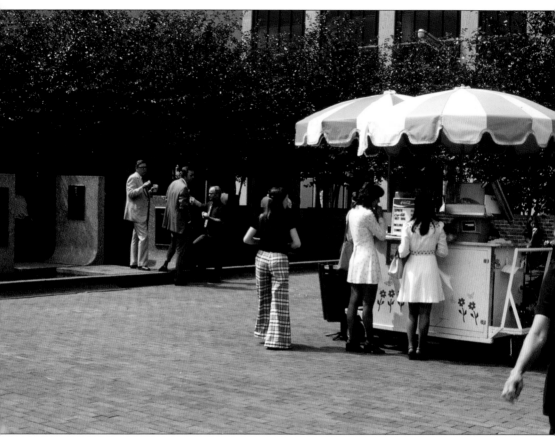

The South Plaza of the Old Capitol Mall has been used as a public space for a variety of purposes, including art shows, concerts, and farmers' markets. Food vendors found the plaza a good site for business on average days when downtown city workers would congregate on their lunch break or on weekends when tourists visited the Lincoln sites. (Sangamon Valley Collection.)

FRONT COVER: People coming through the main gate at the 1971 Illinois State Fair (Sangamon Valley Collection)

UPPER BACK COVER: Eighth Street Mall and Bridge (Sangamon Valley Collection; see page 81)

LOWER BACK COVER (from left to right): Rally at the statehouse (Sangamon Valley Collection; see page 88), Lincoln Monument (Sangamon Valley Collection), Intersection of Sixth and Washington Streets (Sangamon Valley Collection)

CONTENTS

ACKNOWLEDGMENTS

All the images used in this book were provided by the Sangamon Valley Collection (SVC) at Lincoln Library, Springfield's public library. The SVC has an incredible collection of photographs that give details about life in the city of Springfield and surrounding area. Most of these images have been acquired by the SVC through generous donations. The authors would like to thank all of the amateur photographers who took the majority of the images found in this work. The slides they donated to the SVC made this book possible.

INTRODUCTION

Telling the rich and colorful history of a community like Springfield for a 20-year period in just 95 pages is a difficult task in itself. Limited to the photographs available and the space for captions allowed, we have chosen those that best illustrate trends in the 1960s and 1970s. Some are related to the increase in population that followed World War II, others were influenced by a positive economy followed by an energy crisis, and many deal with the impact that the automobile had on America. Photographs with a clear copyright were not always available to represent some of the significant social issues of the time: school busing for desegregation, housing for the elderly and low-income families, equal pay and equal rights. That does not make those issues any less important.

Our subtle theme is the changing environment, changes that were quite dramatic when compared with other eras. We encourage our readers to be viewers, as the pictures tell much more than the captions, showing details such as fashion, car styles, and architecture that were part of the time period.

The city of Springfield has been in transition from its very beginning. Like ripples from a pebble thrown in a pond, the change begins in the center, the downtown area, and works its way out farther and farther. The natural changes as a city grows are the transformation of farmland and timberland into residential and manufacturing areas and, in our case, the introduction of coal mining. For the most part, there were no formal plans as to how the city's growth would be directed and controlled. Through the economic ups and downs of the first half of the 20th century, Springfield grew steadily in population and in its physical boundaries. After World War II, a booming population brought municipal officials to the realization of the need for city planning—planning that controlled through ordinances what could be built and where it should be built, along with planning that addressed social issues and needs, preservation of our heritage, and civic pride.

While Springfield continued to expand outwardly in this time period, great changes were being made that affected the downtown area as shopping, banking, and health care developed into like districts. As the Illinois state capital, tourism has long been a part of Springfield's history; more importantly, it was also the home town of Abraham Lincoln. Visitors have been coming to see Lincoln's home and tomb since Civil War times. Tourism and historic preservation go hand in hand in Springfield, especially when the sites being preserved involve Lincoln. A new awareness of the economic impacts of tourism in this period brought both state and federal government participation in preserving the legacy of Lincoln. The state stepped in and reconstructed the Old State Capitol site, while the federal government created the Lincoln Home National Historic Site.

In the area of education, Springfield experienced the introduction of new institutions of higher education, including Sangamon State University, Lincoln Land Community College, and Southern Illinois University School of Medicine, while at the same time losing Concordia

Theological Seminary. Longtime institutions like the Lincoln Library, State Historical Library, and Illinois State Museum received new facilities with more space to better serve the needs of their patrons. The same could be said for the Springfield Public School District with the addition of a new high school and elementary schools. The nature education movement became easier to teach with the introduction of the Nature Center at the Lincoln Memorial Gardens and the creation of the Henson Robinson Children's Zoo.

From the Illinois State Fair to cultural events and sports, Springfield has had a wide variety of activities and places to entertain its residents and visitors. Old venues such as the Illinois State Armory and the Orpheum Theater changed as one declined in use due to a new convention center, while the other yielded to a new drive-up bank facility.

The images in this book are intended to give a glimpse into what is now a significant period in the history of Springfield, showing economic, physical, and cultural trends that are related on many levels.

One

TOURISM AND HISTORIC PRESERVATION

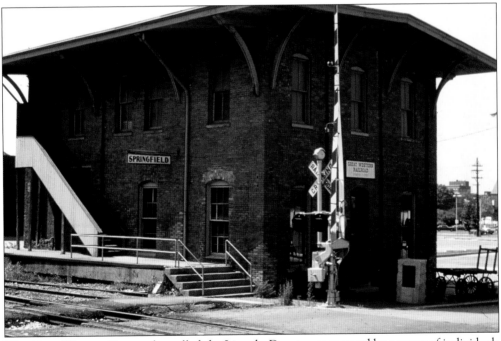

The Great Western Depot, also called the Lincoln Depot, was restored by a group of individuals who wanted to prevent its demolition. This was the railroad depot from which president-elect Abraham Lincoln gave his famed Farewell Address before leaving for Washington, DC, to take office. That speech, it has been said, equals the Gettysburg Address in eloquence. Over the years, the original building was enlarged to two stories and used for freight storage. The group of preservationists led by Joseph Gibbs, Don Adams, and Bill Cellini restored the historic first floor and opened the building for tours in 1965.

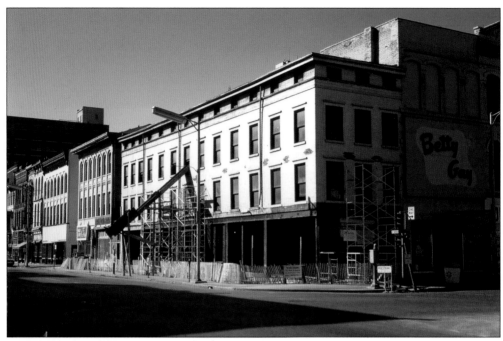

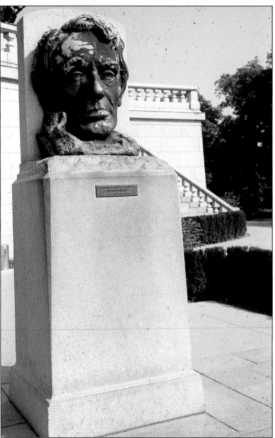

It was obvious to James E. and Edith Myers, Robert and Carolyn Oxtoby, and H.B. and Susan Bartholf that restoration of the only remaining law offices of Abraham Lincoln needed to be pursued. Located on the southwest corner of Sixth and Adams Streets, the group returned the second-floor federal courtrooms and the third-floor law offices to their pre–Civil War appearances.

With "the rub" becoming a common practice, questions arose as to whether it was a way of paying homage to the great orator or just disrespectful. To prevent the rubbing of Abraham Lincoln's nose for luck, the bust designed by Gutzon Borglum at the Lincoln Tomb was raised about two feet in 1970, giving rise to great controversy. Once it had been decided that the tradition was doing no harm and the rubbing was done with affection, the sculpture was lowered to its original height of six feet in 1976.

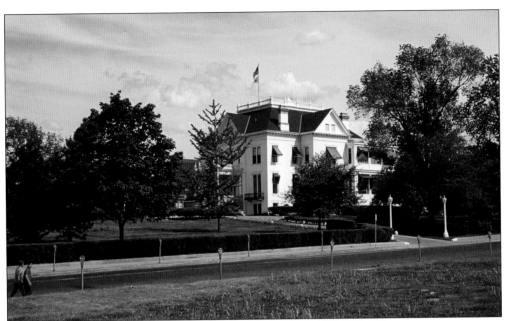

Built in 1855, the Executive Mansion was described as a sagging firetrap, thus Illinois House legislators decided it would be best to tear it down. Catherine Yates Pickering led a movement with public support to restore the building where her father and grandfather (both named Richard Yates) lived as governors. This photograph shows the house as it appeared, white and without a fence, before the early 1970s restoration and expansion.

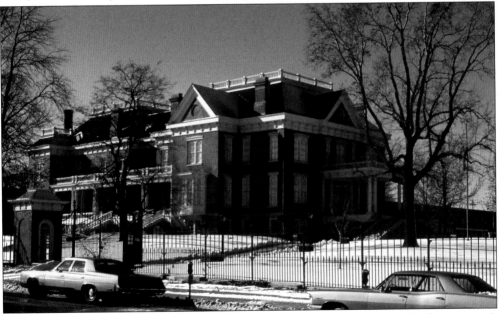

Despite earlier additions, the Executive Mansion had limited private space for the governor's family and houseguests. Holding official functions often called for days of moving furniture to reconfigure an area for use. During the 1971–1972 expansion, Gov. Richard Ogilvie and his wife, Dorothy, were insistent that the historical aspects of the main structure be retained and that the three-story addition match the original exterior style.

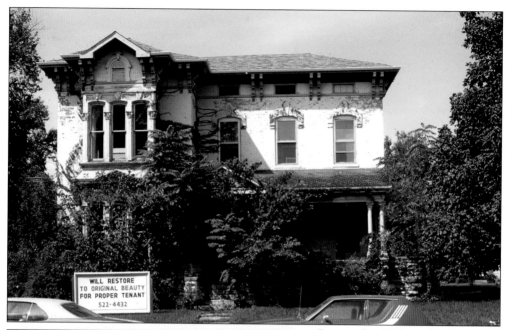

WILL RESTORE
TO ORIGINAL BEAUTY
FOR PROPER TENANT
522-4432

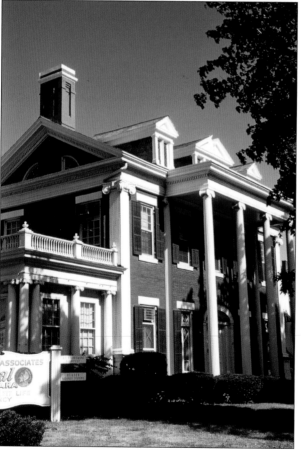

During the 1960s and 1970s, the fate of many of Springfield's historic homes depended on a number of factors, including the condition of the house, its adaptability for reuse, and its location. The two houses shown here found new life after being sold by their resident owners. The Weber House at 925 South Seventh Street (above) became a nursing home in 1955 and remained as such until about 1971. The house then stood vacant until 1978, when it was restored and listed in the National Register of Historic Places. The Vredenburgh Mansion at 1119 South Sixth Street became the offices for an insurance company. A theater group called the Carriage House Players, named for the carriage house on the property, created an outdoor stage that was used for a few performances in the late 1960s.

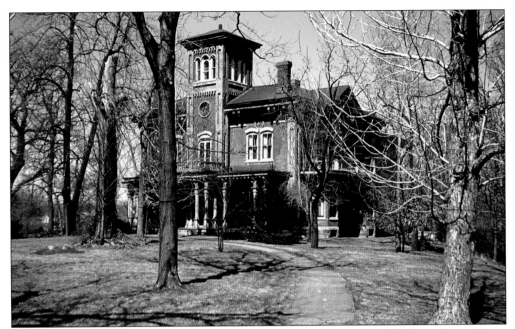

The Diller Mansion at 511 West Carpenter Street was more than a century old when it burned down on November 3, 1968. It had been the home of Isaac Diller from 1880 until his death in 1943. His son Hughes sold the house and auctioned off its furnishings in 1965. New construction was a general reason for the loss of many of the large Springfield homes like the Diller Mansion during this era.

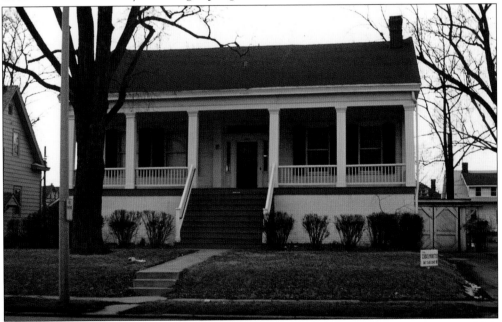

The early Greek Revival style of this house, located at 1825 South Fifth Street at the time of this photograph, caught the eye of many and held the interest of local historians. In 1978, the Elijah Iles House was listed in the National Register of Historic Places. The house was moved twice: once in 1910, and again in 1998 to 628 South Seventh Street, near its original site. The house was opened to the public at its new address.

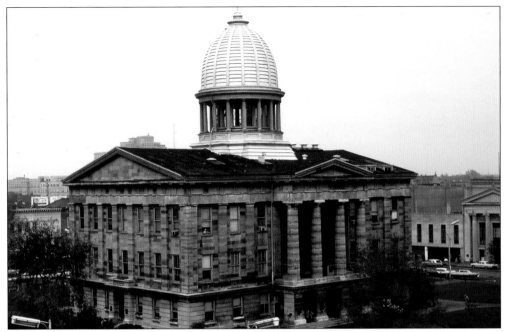

Built in 1840, the fifth capitol building of Illinois, now the Old State Capitol State Historic Site, became the Sangamon County Courthouse in 1876. It had two main levels and a small dome. By 1897, the county needed more space. Recognizing the historical significance of the building to Abraham Lincoln and others, a bold decision was made to preserve the structure yet increase its capacity by adding one level at the base and reconfiguring the dome to balance the taller appearance.

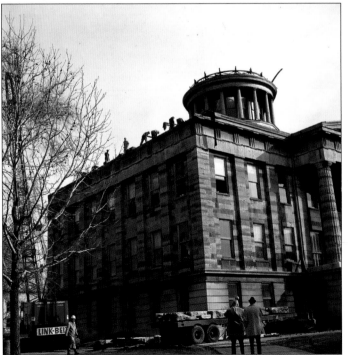

Space and the necessity to modernize had become issues for the county by the 1960s. Because of the changes that had been made to the historic capitol, it was debated whether to save the building or demolish it. The careful demolition seen in this picture has a twist. It was part of a process to save the building so the history associated with the Old State Capitol could be treasured and shared.

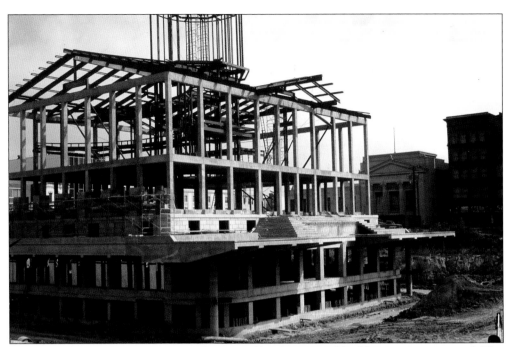

To restore the statehouse as accurately as possible, the original building stones were used. The reconstruction process provided the opportunity to make some non-historical additions underground. Two lower levels made space available for public parking, as well as a location for the State Historical Library and its offices.

An estimated crowd of 3,000 gathered for the dedication of the Old State Capitol on December 3, 1968. While the restoration was only about four-fifths complete, the dedication ceremonies marked the close of Illinois's sesquicentennial year (1818–1968). As a part of the program, Illinois governor Samuel Shapiro and US appellate judge and former governor Otto Kerner made brief remarks before the public toured the building.

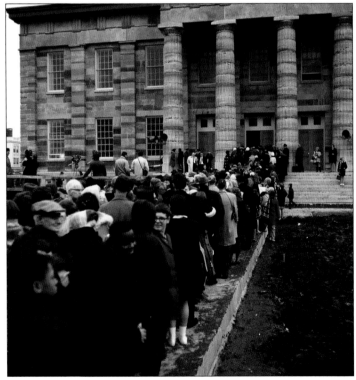

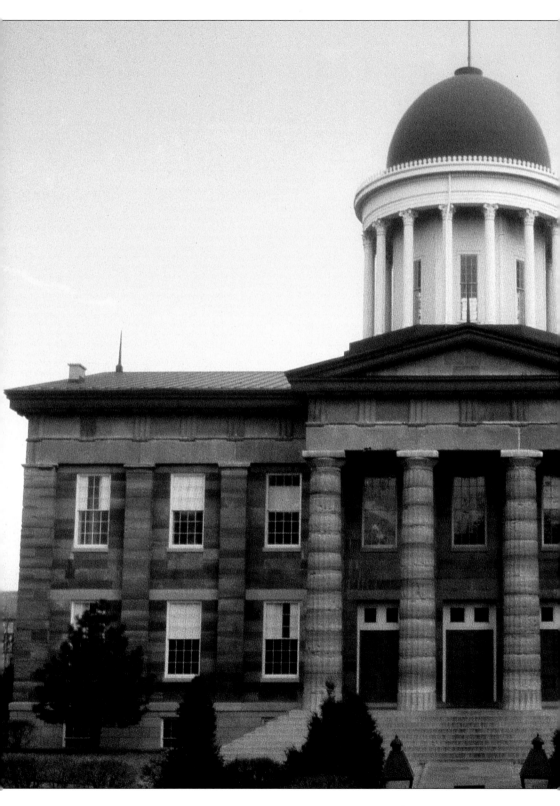

About a year after its formal dedication, the Old State Capitol was completely furnished and opened for daily interpretive tours on November 15, 1969. On the previous day, Gov. Richard Ogilvie and Mayor Nelson Howarth presided over a press preview at which Secretary of State Paul Powell presented the portraits of George Washington and Marquis Lafayette that had hung in the original building when it was the statehouse. These and many other original and reproduction antiques took visitors back in time as they viewed the restored House and Senate chambers, Supreme Court Room, and State Library from which Abraham Lincoln borrowed books. With its new headquarters in the lower level, the State Historical Library was easily accessible for those with a serious desire to learn more about the early days of Illinois and Springfield as the state capital in which Lincoln lived.

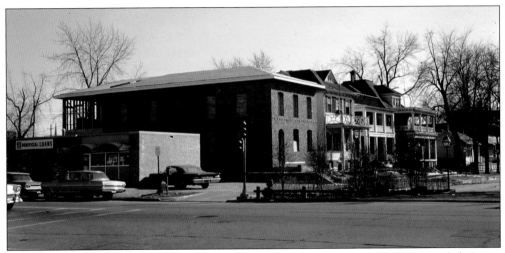

In 1966, a group called Ninian Edwards Inc. built a private museum at 406 South Eighth Street to tell the story of Abraham Lincoln. The redbrick building, shown here under construction, was a scaled down version of the Ninian Edwards house. Lincoln was married in the parlor of the original Edwards house, which was replicated in the museum. Miniature dioramas by local artist Arthur Sieving portrayed major events in Lincoln's life.

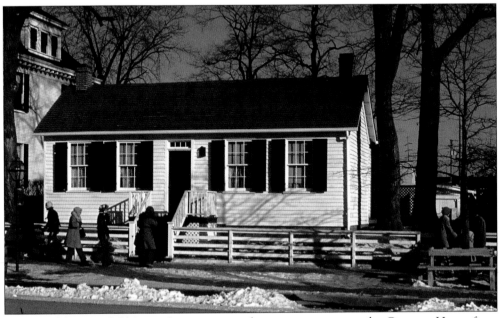

In 1962, the Springfield Junior League received permission to move the Corneau House from the southwest corner of Eighth and Jackson Streets to a lot donated by the Illinois Department of Conservation just north of the Lincoln Home. The house was renovated and opened as the Lincoln Home Reception Center in May 1965.

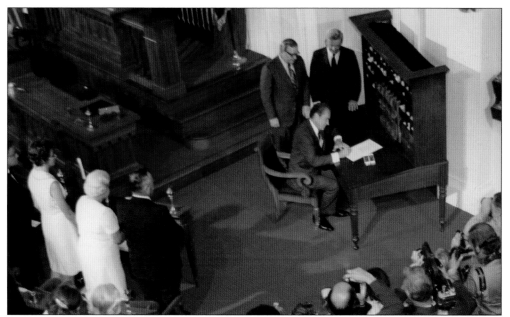

On August 18, 1971, Pres. Richard Nixon traveled to Springfield to sign the bill designating the four-block Lincoln Home area as a National Historic Site. This site became the first of its kind in Illinois. Nixon signed the bill into law at the desk Abraham Lincoln used to write his first inaugural address. The event took place in the Hall of Representatives in the Old State Capitol.

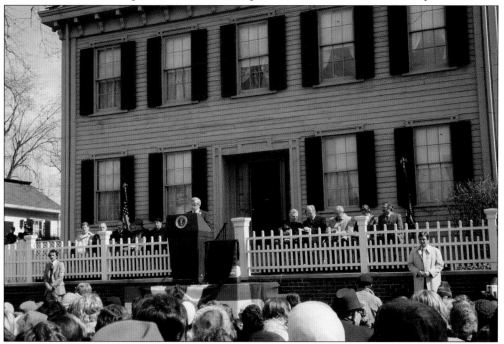

Pres. Gerald Ford made his second visit to Springfield in March 1976 to dedicate the cornerstone of the Lincoln Home Visitor Center, which was then under construction. Ford is shown in front of the Lincoln Home, sitting second from left on the right. The visitor center was officially opened on July 4, 1976, with Congressman Paul Findley leading the ceremony.

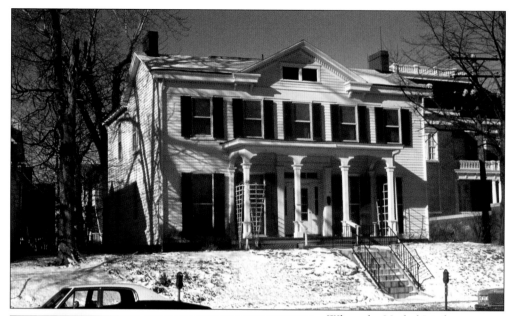

When the Vachel Lindsay Association opened the nationally known poet's home for regular tours in 1960, Lindsay's former high school English teacher, Elizabeth Graham, served as the curator. She proudly told of visitors from all 50 states, along with one from Canada and one from Paris, France. Sometimes referred to as the "wandering minstrel," Lindsay was born and died in this home at 603 South Fifth Street.

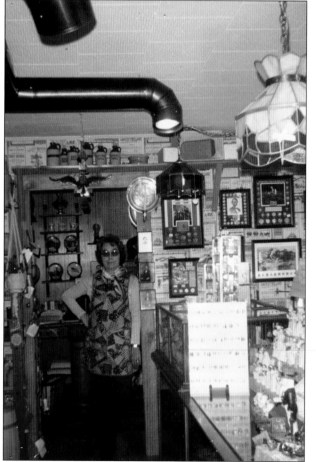

As Springfield's tourism increased, so did souvenir shops. The shop pictured here was associated with the A. Lincoln Wax Museum on the east side of Ninth Street, near the Lincoln Home. Reportedly, the wax figures sculpted by Henry Geving were quite accurate and placed in tableaus that contained a number of authentic period pieces.

Two

EDUCATION

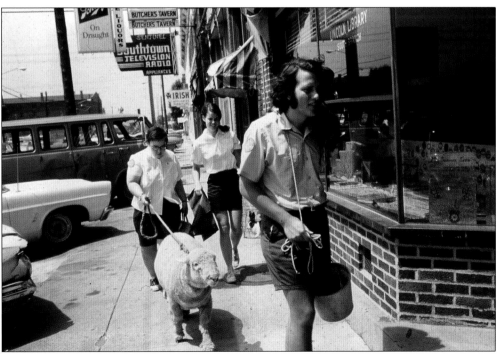

The Henson C. Robinson Children's Zoo opened in June 1970 on 10 acres of land donated to the Springfield Park District by the City of Springfield. The zoo was named after Park District president Henson C. Robinson, who was the planner and original sponsor of the zoo. Employees of the zoo are shown bringing animals to the Lincoln Library's South Branch at 1121 South Grand Avenue East to meet children.

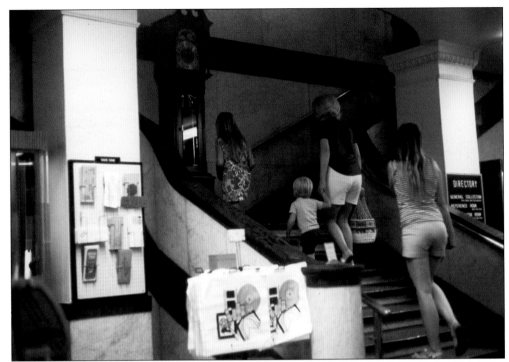

The grandfather clock and the marble-lined stairs in the Lincoln Library Carnegie building were familiar to librarygoers, as most of the items in circulation were located on the second floor. Another memorable aspect of the library were the glass floors in the stacks where the older fiction could be found. Those floors created enough static electricity to give a surprise shock.

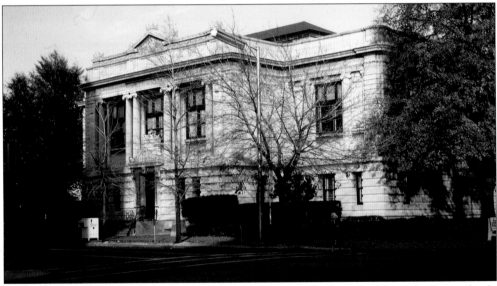

Overcrowded almost as soon as the 1904 building opened, the Lincoln Library had to make do for many years. The Andrew Carnegie–funded building was designed for grandeur, with interior columns, arches, high ceilings, and fireplaces, rather than for the needs of a growing collection. Eventually, staff work areas were relegated to an unpleasant basement. Remodeling the inefficient building was found to be too expensive, so it was razed in 1974.

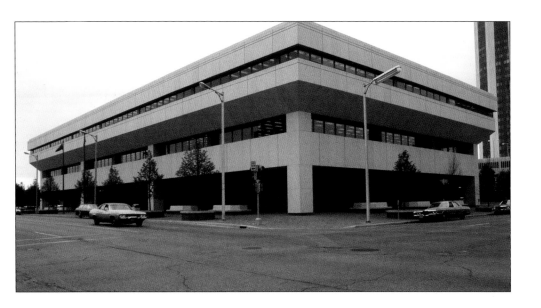

The Lincoln Library officially opened the doors to its new building on February 21, 1977. Designed to house 435,000 books, the three-story structure stood on a half block with an underground parking garage and 94,500 square feet of space. The building was recognized for its heating and cooling system, which was designed to use the latest energy conservation techniques. A featured element of the interior was a freestanding stairway lined with red carpet to access all three floors. A skylight of geometrical design provided daylight above the stairway. A nearly column-free interior was designed to provide flexibility for the library's future needs.

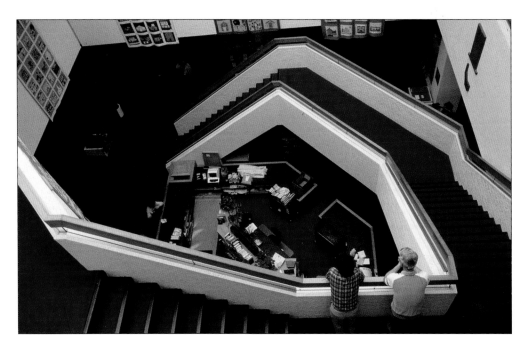

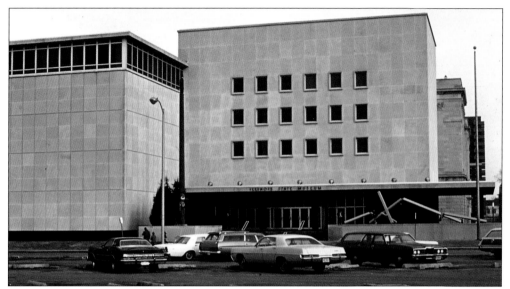

Ground-breaking ceremonies were held for the new Illinois State Museum at 502 South Spring Street on January 1, 1961. The three-story building intentionally lacked windows to prevent sunlight from damaging documents and exhibits. Formerly housed in the neighboring Centennial Building since 1922, the museum opened its doors on February 4, 1963.

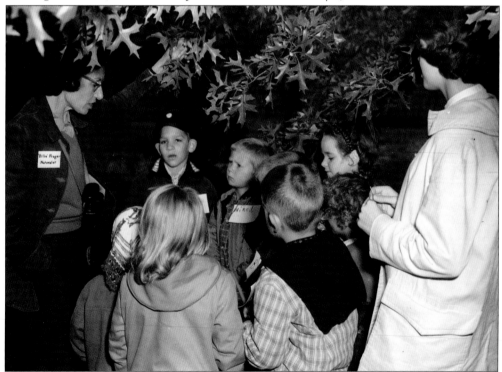

Seeing a need for a nature education program in Springfield, the Abraham Lincoln Memorial Gardens Foundation started planning for a new nature center at the site and hired a naturalist to teach the importance of natural resources to schoolchildren. The nature center opened on the first day of spring in 1966. Here, naturalist Sibyl "Billie" Prager talks to a group of young visitors.

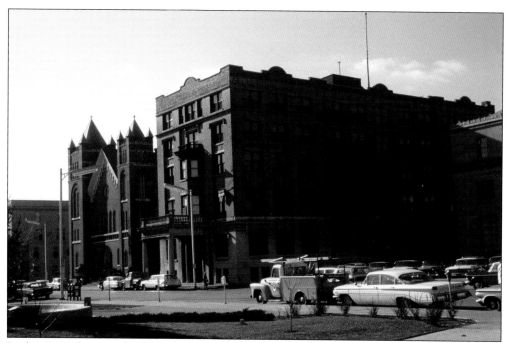

In this 1962 photograph of South Seventh Street, the old YMCA building, seen just to the right of the First Presbyterian Church, is readied for demolition. Judged too dangerous to take down with a ball and crane, the structure was instead taken apart with maul and bar. It had "beautiful lumber," according to the salvage contractor. The church purchased the site for an education and congregational activities center.

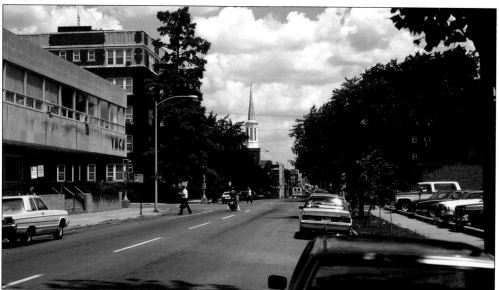

Dedication ceremonies for the new YMCA facility were held on November 25, 1962; however, parts of the building at 701 South Fourth Street were already in use. The organization was proud of its ability to now place more focus on boys and youths while still maintaining space for adults. Among the areas provided were game rooms, gyms, swimming pools, handball courts, lounges, music areas, and a chapel.

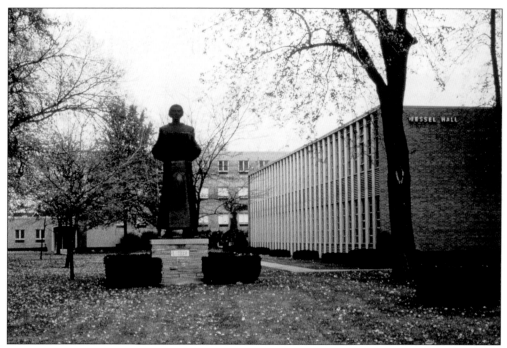

The 12-foot statue of Martin Luther towers near the modern Wessel Hall, both of which were part of the growth Concordia Theological Seminary experienced in the 1950s and 1960s. In 1975, a hundred years after moving to Springfield, the Missouri Synod determined that the Springfield location lacked room for expansion and was too close to the St. Louis Seminary. The seminary closed in August 1976 and moved to Fort Wayne, Indiana.

Enrollment was rising rapidly at Springfield Junior College, and the administration responded with a new science building and the new Charles E. Becker Library, shown here in 1967. With a new local junior college set to open in the fall of 1968, it was deemed advisable to change the school's name to Springfield College in Illinois, dropping the word "junior."

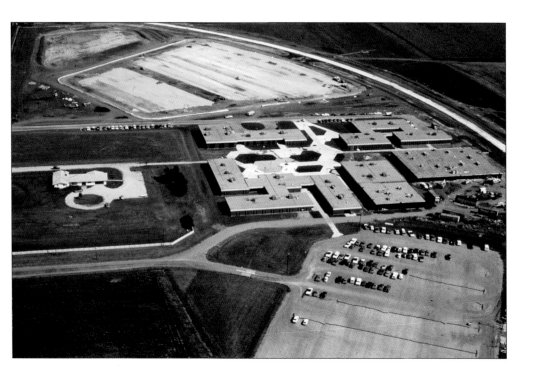

The Illinois General Assembly created the Sangamon State University and Lincoln Land College in the late 1960s to serve as an upper-division public affairs university and a junior college. A site consisting of more than 1,000 acres just west of Lake Springfield was purchased for both campuses. Sangamon State occupied a 745-acre tract on the northern side of the property. This aerial view from the early 1970s shows the original cluster of buildings that served students of the young institution. Lincoln Land was first housed in six temporary classrooms and office buildings constructed northeast of the intersection of Route 66 and Hazel Dell Road. Classes began on September 23, 1968.

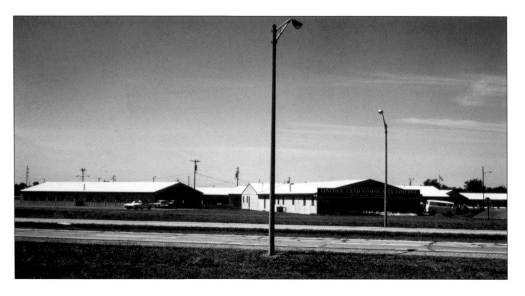

After the opening of Southeast High School, the former Feitshans High School building was converted to the area vocational center. It was also used as a recreation center for the Springfield Urban Coalition. As part of the Springfield Public School District's integration plan, the building became a seventh grade center.

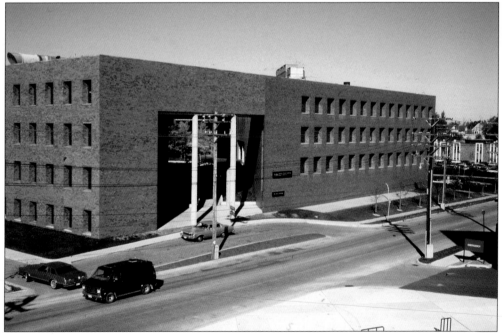

In an effort to produce more men and women who could provide health services in the state, Southern Illinois University acted upon a recommendation of the Illinois Board of Higher Education in 1969 to establish a medical curriculum capable of graduating 50 students a year. The site of the former Reisch Brewery was selected as the new campus, and construction was begun in 1971.

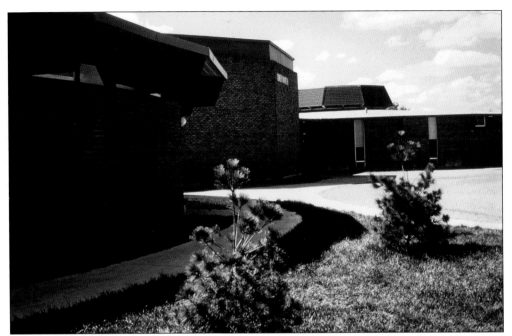

The Owen Marsh School was one of the new elementary schools built in the mid-1960s to accommodate the students living on the expanding edges of town. The school was named for a member of the Springfield Public School Board who died on December 29, 1964. Springfield educator Susan Wilcox was also honored with a school in her name.

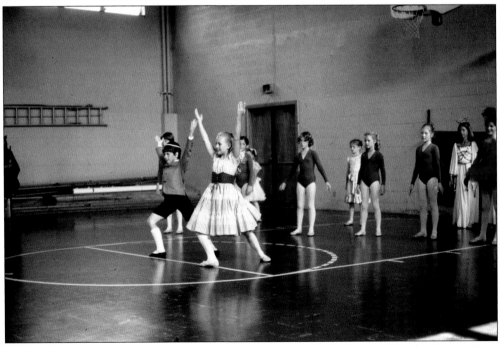

Interest in ballet and other fine arts grew in the 1960s and 1970s. Groups like the Copper Coin Regional Ballet and Ballet Concert Group blossomed during this time. One of the objectives of the Ballet Concert Group was to perform for civic groups, clubs, and schools.

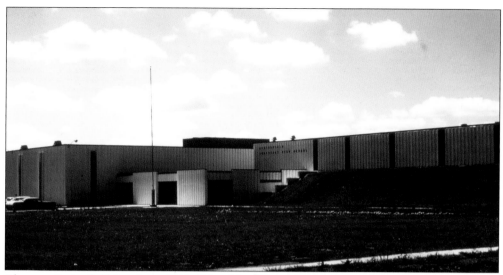

The new Springfield Southeast High School benefitted from a fully air-conditioned building, as well as updated electronic and science equipment. The classrooms, designed for both small and large group instruction, were situated around a central courtyard that provided a student lounge area and shortcuts to the various wings of the building. The school's one-story appearance was due to its expansive landscaping, but it was actually two stories with a limited number of windows.

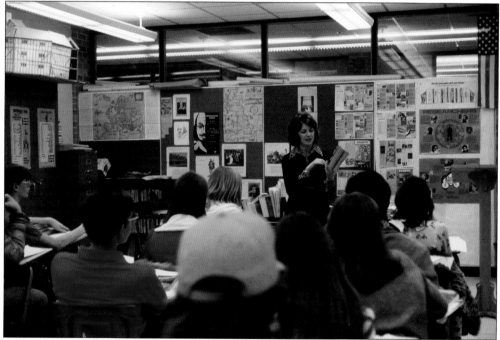

With the increased number of baby boomers in attendance at Springfield high schools, new additions were made to the Springfield and Lanphier High Schools. The new Southeast High School was built at the corner of Taylor and Ash Streets. Despite being new, the high school's enrollment was already at capacity when it opened in 1967. Split attendance times separating freshmen and sophomores from juniors and seniors was the first potential solution for overcrowding at Springfield and Southeast High Schools.

Three

ENTERTAINMENT

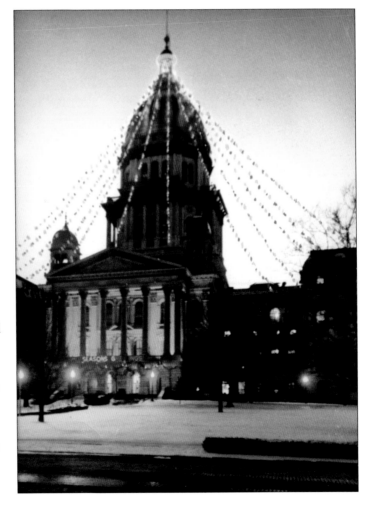

Illinois secretary of state Charles Carpenter is credited with the idea of decorating the statehouse dome with strands of Christmas lights strung from the top of the dome to the roofs of each wing in 1962. The strands contained some 1,000 blue, yellow, and red bulbs. The view was noted to be especially striking from a distance—as far as five miles away—as well as from the air. The lights were hung every holiday season until 1974, when they were replaced with other decorations because of the ongoing energy crisis. The lights were brought back in 1979.

Springfieldians were strong supporters of Christmas parades, with crowds estimated in the thousands eagerly watching for the next float or band to come down the street. Not every year was fortunate to have a Christmas parade. Santa, however, always made an appearance. One year, he arrived both at the new Town and Country Shopping Center and then by helicopter to light the Christmas tree on the public square.

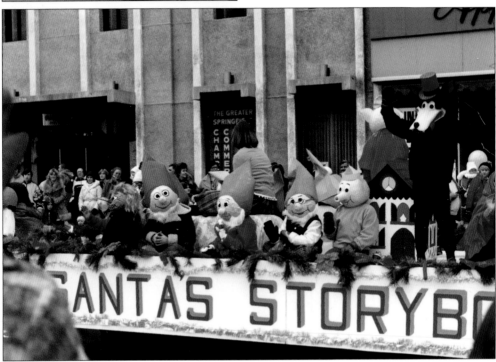

Santa's Storyland was the theme of the 1978 downtown Christmas parade. It featured some 85 giant heads and figures, a circus wagon, and floats from a professional parade company. The local entries included marching bands, horseback riders, homemade floats, and of course, Santa Claus, who thrilled the children. The Springfield Jaycees, the Springfield Central Area Development Association, and the Downtown Retail Council sponsored the event.

Teen dances were popular during the 1960s and 1970s. Local bands like Dean and the Sinisters had regular gigs performing for local youth clubs and schools. Led by Dean Huston, the band took second place at the 1969 Battle of the Bands competition at the Sangamon County Fair. The band changed its named to Bearded Clam in 1970.

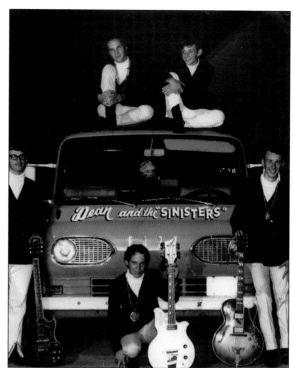

Two drum and bugle corps, the Falcons and the Capital Chargers, were founded in Springfield during the late 1960s and early 1970s, as seen here. Lots of practicing and fundraising were necessary to keep these groups in operation. The warm-weather months meant busy schedules full of parades, concerts, and competitions. The two groups merged in 1974 to become the Statesmen Drum and Bugle Corps.

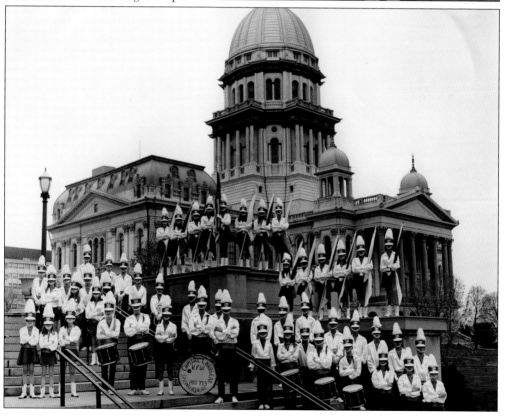

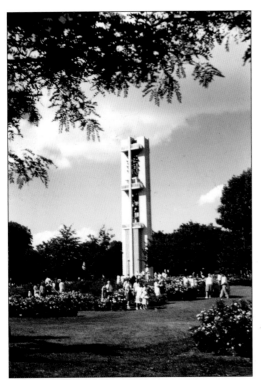

Illinois State Register publisher and state senator Thomas Rees and his wife, Lou, traveled extensively, paying particular attention to bell towers. At the time of his death in 1933, Rees left funds in a trust for a carillon to be built after 1960. Despite the need for a civic center and other public improvements, Rees's wishes were upheld, and in 1962, a 12-story tower with 66 bells was dedicated in Washington Park.

The Washington Park Horticulture Center was expanded in 1971 to include two new greenhouses and a conservatory. The bulbs and cuttings that beautify the park's flower beds were stored or propagated in the greenhouses. The 25-foot-high Plexiglas domed conservatory offered a 50-foot diameter interior space for flower shows and other exhibits. The grand opening in 1972 featured a large bank of Easter lilies, azaleas, and other spring flowers.

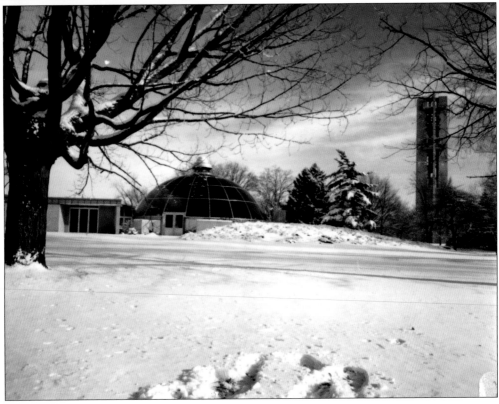

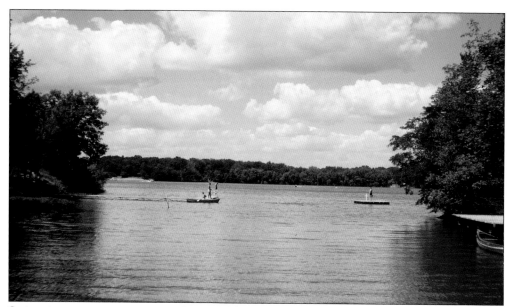

Swimming opportunities grew in Springfield with the completion of the Eisenhower indoor pool in 1969 and the three outdoor pools that opened with the construction of the Nelson Center in 1975. Lake Springfield offered public sites for swimming at the Lake Beach House and Bridgeview Beach. Campgrounds like those used by the Boy Scouts, shown above, were also located on leased land around the lake.

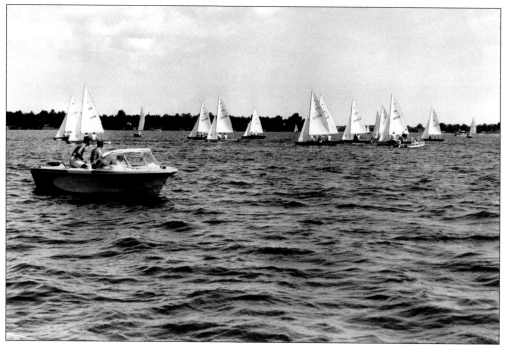

The Island Bay Yacht Club has hosted sailing regattas on Lake Springfield since 1939, when the first event was held with 12 entries. By the 1960s, the Middle State Championship Regatta had attracted more than 150 boats, including entries from many of the surrounding states. Boating in general grew in popularity on the lake.

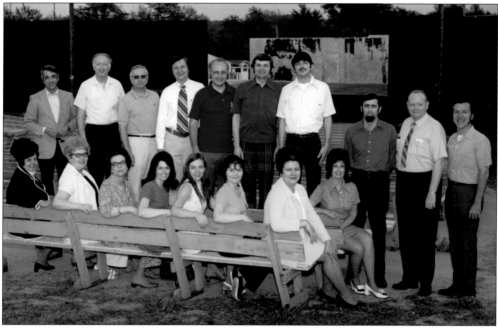

The Springfield Municipal Opera dates to 1935, but not always at the Lake Springfield site. The opera company acquired a lease for 55 acres of land off East Lake Shore Drive and was about to lose it in 1964 after some unsuccessful ventures. Tom Shrewsberry took control and produced a reorganization plan. Since then, the Muni has become a staple for summer outdoor theater. The 1972 board of directors is pictured.

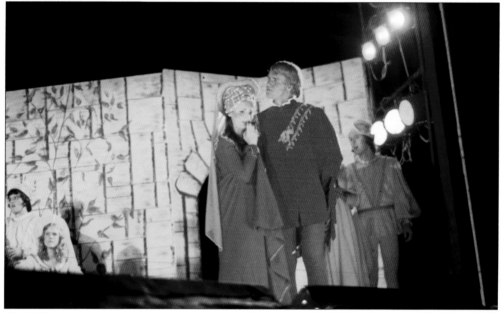

The 1973 season of the Muni Opera opened with the musical *Once Upon a Mattress*. The Springfield area boasts a wide range of talented individuals able to handle Broadway musicals. More than 10,000 hours go into the average production, including not only rehearsals but also the volunteer work needed to build sets, help with costumes, man the concession stand, and so on.

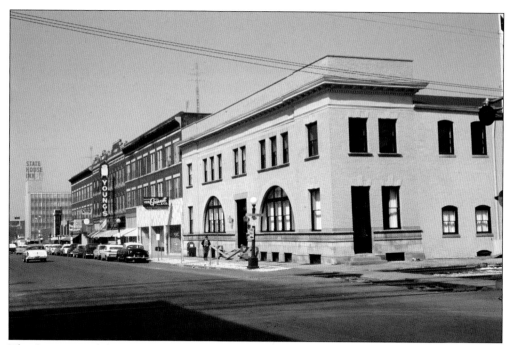

The Sangamo Club purchased this former power plant warehouse at the northwest corner of Third and Adams Streets in 1963. The building was completely renovated with a main dining room featuring walnut wood accents and red wall-to-wall carpeting. Other areas included a men's bar and grill, two lounges, and a basement game room.

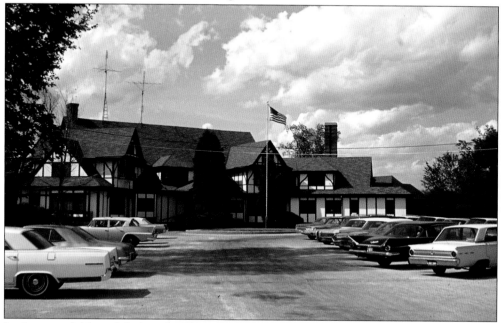

Looking much like it did when the Illini Country Club opened in 1906, the clubhouse underwent major renovations in the 1960s. The club also modernized the entire golf course over a three-year period and rebuilt its swimming pool. The golf course was used for district qualifying play for the US Open tournament.

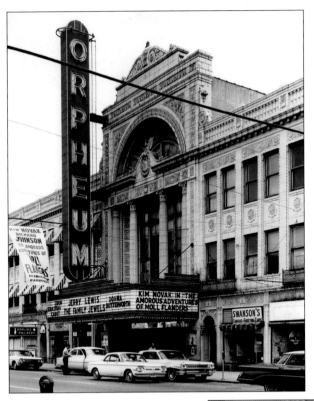

The Orpheum at 122 North Fifth Street was built for theatrical performances (mostly vaudeville), with a full stage, orchestra pit, and a pipe organ for music during intermission. Many big-name performers appeared on its stage. Besides the famous performers, the Orpheum was known for its decor, featuring travertine marble floors, crystal chandeliers, antique furnishings on the mezzanine lobby level accessed by a double set of sweeping staircases, and a luxurious gold, red, and ivory color scheme.

Most of those who attended a performance or a movie at the Orpheum agree that the demolition of the theater was an irreplaceable loss for Springfield. The novelty of television had dulled interest in theaters. In August 1965, the five-story building was taken down to make way for a banking facility.

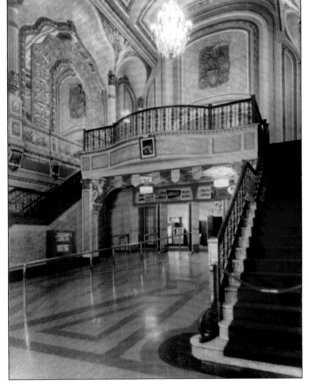

Golf was a popular sport in Springfield during the 1960s and 1970s. The Ladies Professional Golf Association tournament at the Rail Charity Golf Classic started in 1971. The first-ever Lincoln Greens Golf Tournament was held in 1974. From left to right, Joe Aidich, Joe Firth, and J.R. Fitzpatrick were the winners in their age divisions.

Soccer participation began to grow in Springfield with the popularity of the Sangamon State University soccer team and the creation of the YMCA youth soccer program in 1967. By 1974, a total of 700 kids on 34 teams were involved in the program. Soccer programs were added to the three public high schools in 1976. This photograph shows the members of the 1971 YMCA men's soccer squad, which represented 12 different nationalities.

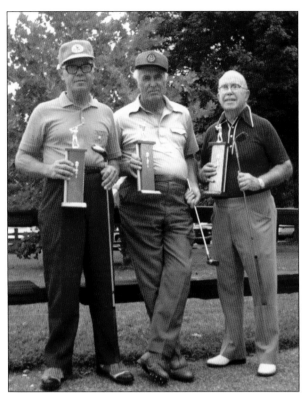

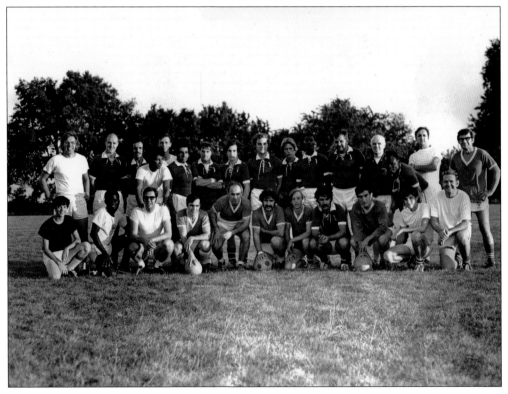

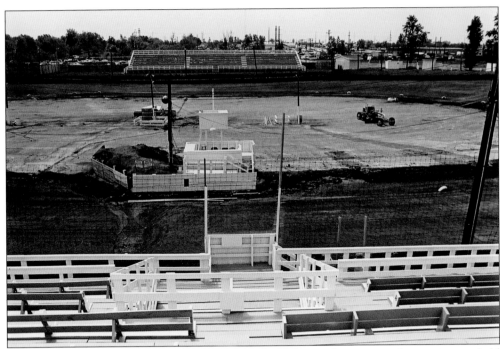

The roar of engines was a familiar sound every weekend during the summer when racing was held at the Springfield Speedway, located at the intersection of Clear Lake Avenue and Highway 66. Owner Joe Shaheen opened the speedway in 1948. Shaheen began racing cars in the late 1920s and had been promoting stock car races since 1950. The speedway hosted different types of races for categories such as modified, hobby, and streetcars.

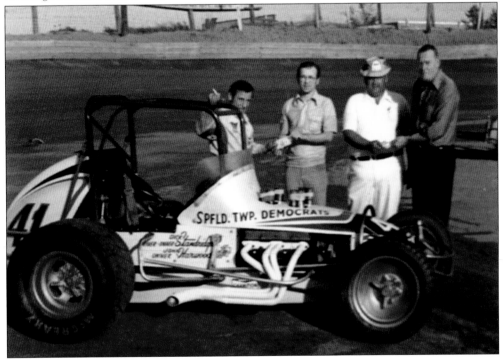

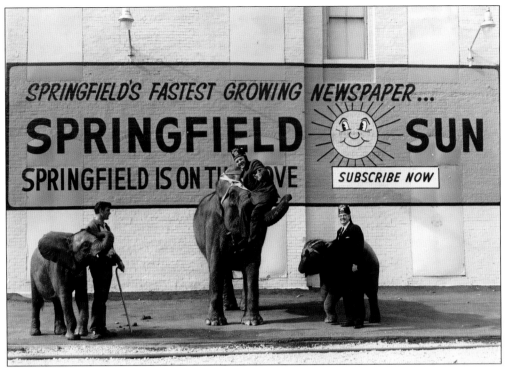

The days of the big circus tents setting up on the grounds at Eleventh and Black Streets or at Wabash Avenue and Chatham Road were disappearing, replaced by large indoor venues. When the Ansar Shriners brought the Polack Brothers Circus to the armory, the Sangamon County Highway Garage served as the boarding area for the animals, including a three-and-a-half-year-old African elephant named Kenya in 1966.

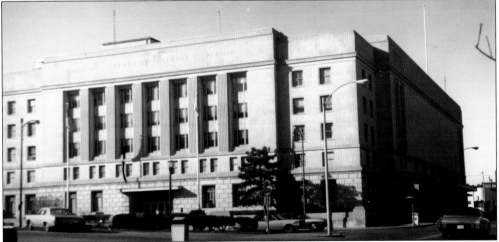

Built in 1936, the Illinois State Armory at Second and Monroe Streets provided facilities for the National Guard as well as a 6,000-seat auditorium space. The events held there were innumerable, including annual children's Christmas parties, city and sectional basketball tournaments, circuses, gubernatorial inaugurations, high school baccalaureates, political conventions, and sometimes boisterous rock concerts. With the opening of the Prairie Capital Convention Center, the venue for these types of events began to change.

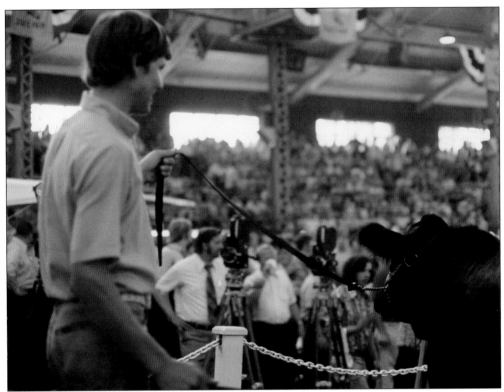

The judging of livestock, produce, and other items has been part of the Illinois State Fair since its beginning in 1853. By the 1960s, a large number of categories had been added. One of the highlights of the fair is the Sale of Champions, in which the grand champions of the animal groups are auctioned off to buyers from all over the state. These prize animals usually include hogs, cattle, and sheep, but chickens and rabbits were added to the auction in the 1970s. Another favorite aspect of the fair is the Grand Champion Bakeoff. Started in 1968, this competition pits the winners of various baking categories against one another for the top baking prize.

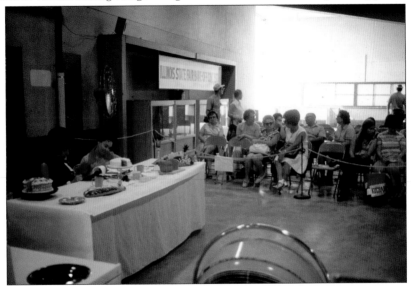

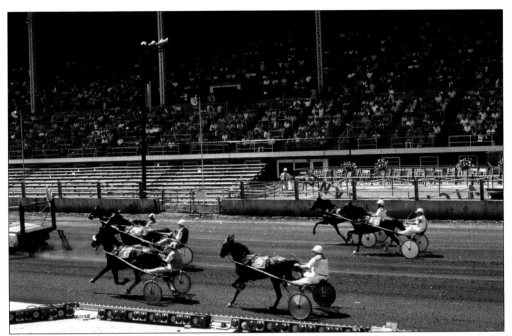

Despite the lack of pari-mutuel betting at the Illinois State Fair, horse racing was popular. Large purses were offered from levies on track wagering in Chicago. August 18, 1976, proved to be a historic day of harness racing when a duo of two-year-old pacers broke the track record one race after the other in under two minutes, at 01:55.6 and 01:55.

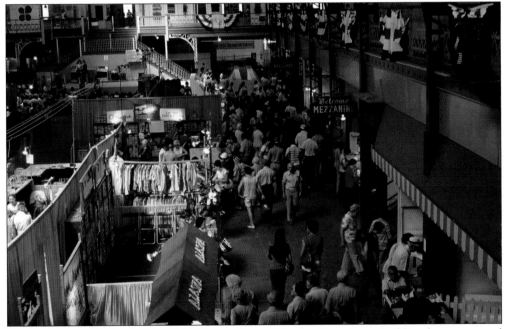

Since its construction for the 1894 Illinois State Fair, the Exposition Building has continued as a centerpiece structure for fairgoers. Initially, exhibitors showcased their handiwork—quilts, jellies, garden crops, and more. In this 1977 scene, personal entries were replaced by vendors who demonstrated and sold the latest kitchen gadgets, unique clothing, appliances, and so on.

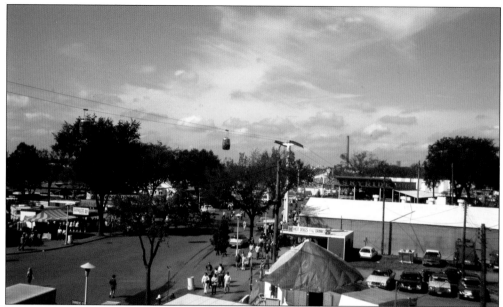

The familiar sky ride at the Illinois State Fairgrounds was added in 1968, providing a view of the activities from 50 feet in the air. Stretching a half mile, the ride took fairgoers from Gate No. 1 to the grandstand. The 150-foot slide located near the main gate was another new addition to the fair that year.

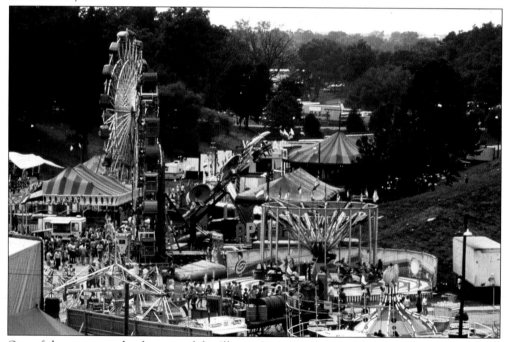

One of the most popular features of the Illinois State Fair, Happy Hollow is shown here in all of its glory with colorful rides and shows. This area has been referred to as Happy Hollow since the state fairgrounds were permanently located in Springfield in 1894. Happy Hollow became the official name of the area in 1907 when the carnival and shows were moved from downtown Springfield to the new amusement grounds.

Four

COMMERCE

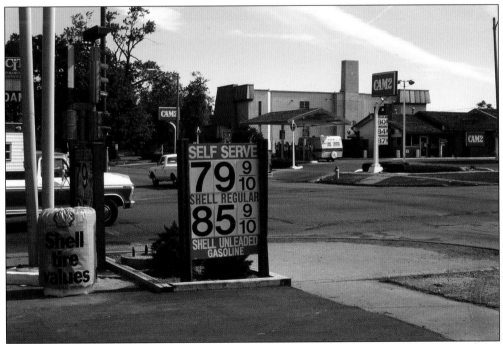

The rise in the price of gasoline, especially during the energy crisis of the 1970s, was important to Springfield drivers, as well as to others across the nation. Service stations were charging about 33¢ a gallon in the early 1960s. Minor price wars could start at a moment's notice if the major oil companies dropped the price by a few cents. Price controls also played a role in the early 1970s. By that time, the cost had jumped to 48¢ a gallon. Prices continued to rise through the late 1970s, as seen on this sign with 79¢ for regular and 85¢ for unleaded.

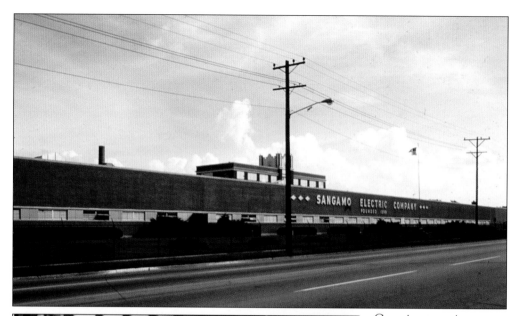

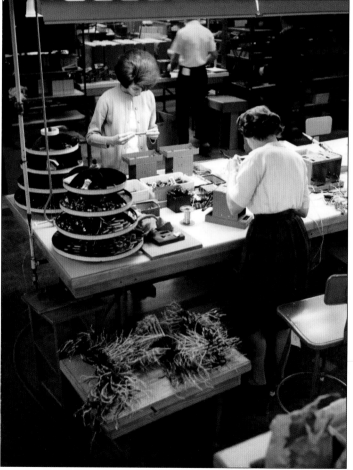

Covering two city blocks, the Sangamo Electric Company was a large presence on the city's north side. It was known for its electric meters but made numerous other products like transformers, data instrumentation recorders, and sonar. Once employing thousands of workers, the plant had less than 1,000 employees when it was sold to Schlumberger in 1975. Many of these workers spent their entire careers at Sangamo, becoming members of the 15-year and 35-year clubs that recognized their dedication. The Springfield plant was closed in July 1978 with production moving to the state of Georgia. Workers at the plant said the company moved to the South for higher profits and to get away from unions.

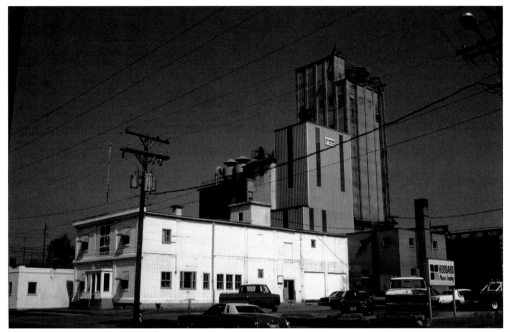

Springfield's early economy focused on serving the surrounding agricultural community. Part of those services was milling flour. Over the years, the flour mills were converted to milling grains for livestock feed. In 1968, Hubbard Mill of Minnesota purchased the Faultless Milling Company. They were already operating the old Gainer feed plant in Springfield and planned to continue producing and selling feed there.

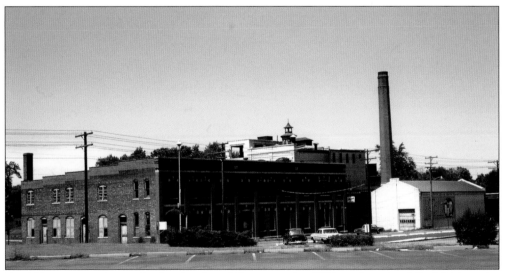

For 117 years, weathering both a local prohibition in the 1850s and national Prohibition, the family-owned Reisch Brewery produced beer and malts under labels such as Gold Top, Sangamo, and Bohemian until 1966. Unable to compete with the larger breweries, Reisch closed, and Memorial Hospital acquired the six-acre production site. Later, the Southern Illinois University School of Medicine was built there.

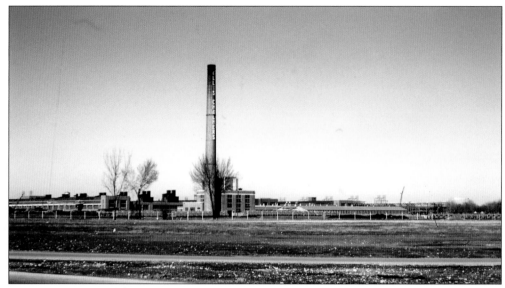

An important part of the manufacturing sector since 1928, Allis Chalmers occupied a large tract of land on the city's southern edge, where it made crawler tractors and road-grading equipment. The plant employed as many as 3,500 people during that time. The company consolidated five construction machinery plants into two production plants, one of which was in Springfield. The division headquarters moved to Springfield in 1968.

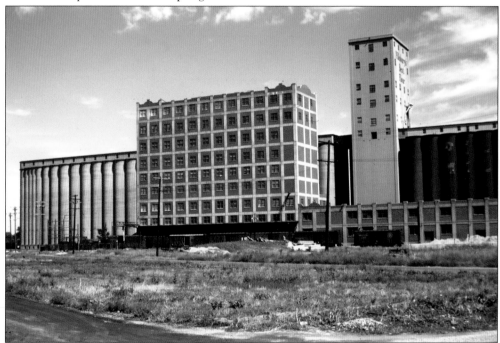

The 1960s began optimistically for Springfield's Pillsbury flour mills, grain elevators, and grocery plants located at 1525 East Philips Street. A nine-story building was constructed in front of the one seen here to accommodate the increased demand of consumers willing to buy convenience products like cake mixes. Employee numbers began to decline, however, due to advanced automation and computer-operated equipment, increased production expenditures, and labor issues.

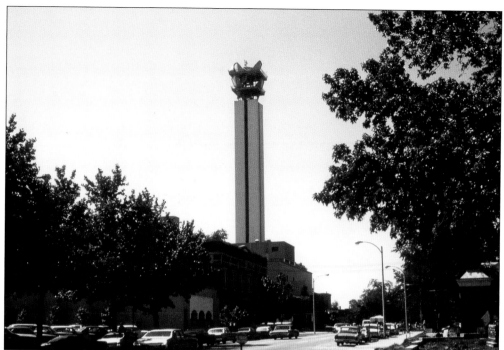

Springfield became the downstate headquarters for Illinois Bell Telephone in the early 1960s, bringing in some 350 jobs. At that time, the Lakeside and Kingswood prefixes on Springfield telephone numbers were eliminated, and seven-digit numbers replaced them. Touch-tone phones were introduced, along with self-dialed long-distance calls. A 245-foot microwave tower at Fifth and Cook Streets made Springfield a switching center for massive amounts of communication signals—radio, telephone, and data.

In 1955, Franklin Life Insurance Company was the first nongovernmental entity to install an "electronic brain," the giant Univac. By 1966, the company had set up its third addition to the digital system that stored information on tape. The size of these computers meant an additional building. By 1970, the number of requests for computing services had resulted in a subsidiary business, Franklin Data Services, to coordinate the development and sale of computer services.

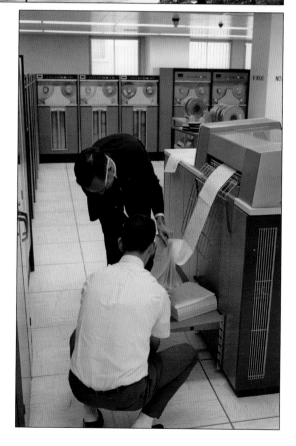

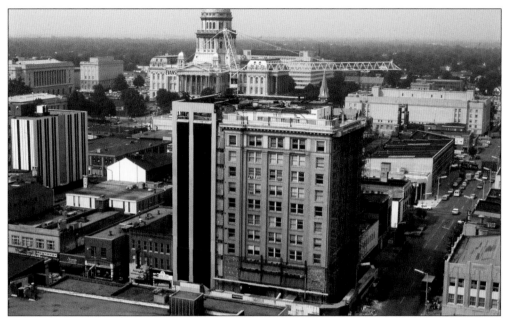

The First National Bank, located at the southwest corner of Fifth and Adams Streets, has undergone three major remodeling projects since 1921. The last renovation started in 1972 and cost an estimated $4.5 million. The building was expanded with a unified exterior design. The new facade of precast concrete columns and bronze glass can be seen as it begins to cover the older portion of the building.

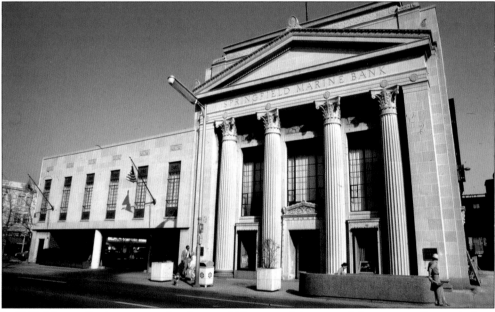

In 1960, Marine Bank announced a plan to add four new drive-up and three new walk-up windows and a new 20-car parking area. The addition was constructed in the space between the existing bank building and the Strand Theater. The building process was accompanied by music provided by the Muzak Corporation as a way to lessen the din of the construction noise. The facility opened on February 15, 1961.

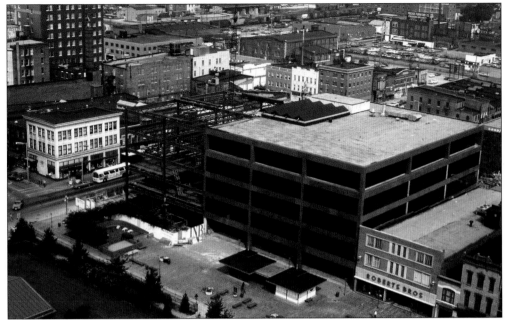

In 1972, the Illinois National Bank started construction of a new building called the INB Center. The first phase of the plan established part of the new structure to the east of the old bank building at the northeast corner of Fifth and Washington Streets. The bank moved into this section once it was finished so the old building could be demolished to make way for the second phase of construction.

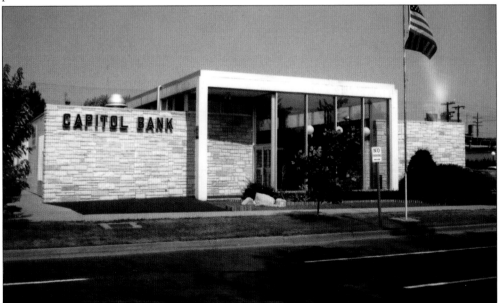

Capitol Bank, located at the corner of Sixth Street and Laurel Avenue, started in 1955 as a suburban bank offering drive-up services. The bank celebrated its 10th anniversary in 1965 with an open house for the new building shown here and what was described in the local newspaper as one of "the most extensive drive-up banking facilities in central Illinois." The bank was proud of the service provided with seven drive-up windows.

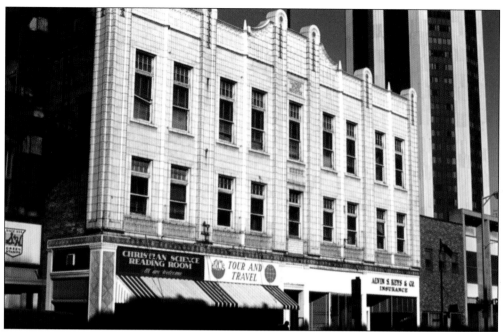

The white terra-cotta structure known as the Register Building on East Monroe Street had not been used by the *Illinois State Register* since 1942. In that year, Copley Press, owner of the *Illinois State Journal* since 1928, leased its competitor, the *Illinois State Register*. Col. Ira Copley moved the *Register* into the Journal Building at 309–315 South Sixth Street (below) but maintained the two publications as separate papers except for the Sunday edition. The *Illinois State Journal* was the morning paper with a Republican slant, while the *Illinois State Register* was the evening paper with a Democratic voice. By 1974, so many stories had been duplicated between the two papers that the decision was made to merge as the *State Journal-Register*. The Register Building, pictured above, was actually a set of five mid-1800s structures that shared the same 1920s terra-cotta facade. They were razed in 1985.

Two newspapers were founded in Springfield during this period. The *Springfield Sun* was started by the Astro Publishing Company in 1964 and ended publication in 1973. The *Illinois Times* was founded by Bill Friedman and Alan Anderson in September 1975 as a weekly alternative newspaper. Fletcher Farrar, the present owner, bought the *Times* in 1977.

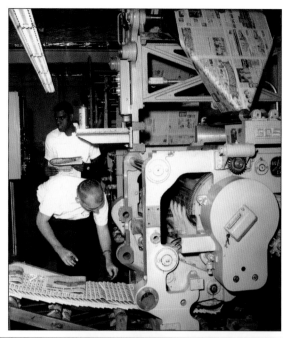

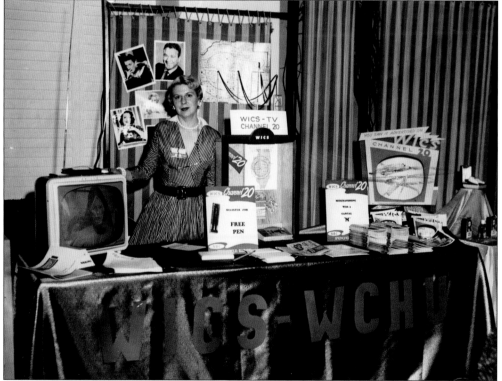

Advertising is the lifeblood of the media. LuAnn Miller from the WICS television station is seen here in a booth set up for potential advertisers. The local station probably lacked concern for competition from cable television, which began serving the Springfield market in 1967. Only 275 city residents began watching television via cable at that time.

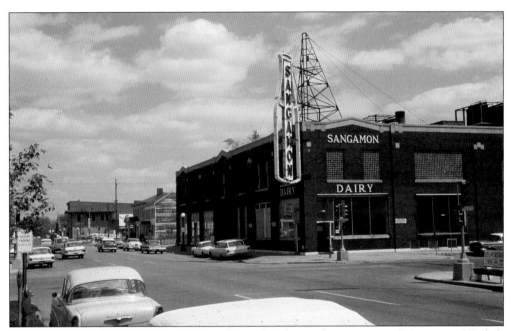

Opened in 1923, the Sangamon Dairy was located at the southeast corner of Monroe and Eighth Streets on the former site of a feed yard. It was a popular hangout for those looking to socialize and enjoy ice cream. The dairy was demolished in 1963 when Sangamon County acquired the property as the site for the new county building of 1966.

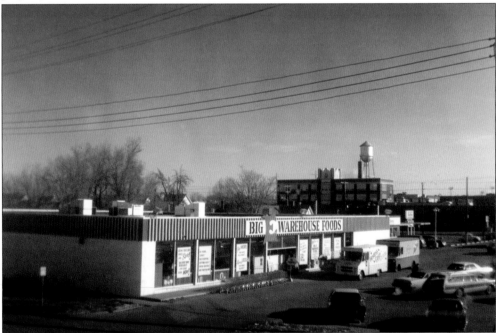

Discount food stores, with their generic brands and limited services, began to appear in Springfield in the late 1970s. The Eisner chain started one such store, Big E Warehouse Foods, in 1977. The grocery store, located at 801 East North Grand Avenue, lasted only a few years before closing. Noonan True Value Hardware purchased the building in 1981 and continues to occupy the site.

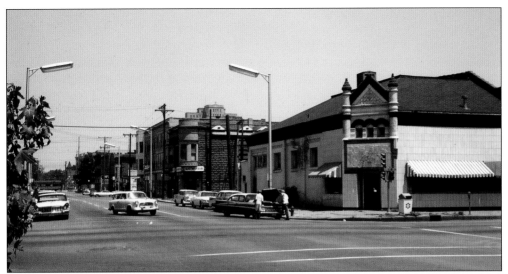

Roberts Fish Market was a family-owned business at 701 East Washington Street until a federal urban renewal project was proposed to redevelop a commercial block. The city purchased the building, and the company rebuilt its wholesale and retail business at 1615 West Jefferson Street. The Horace Mann Insurance Company was established as part of the redeveloped block bordered by Seventh and Eighth Streets and Washington and Jefferson Streets.

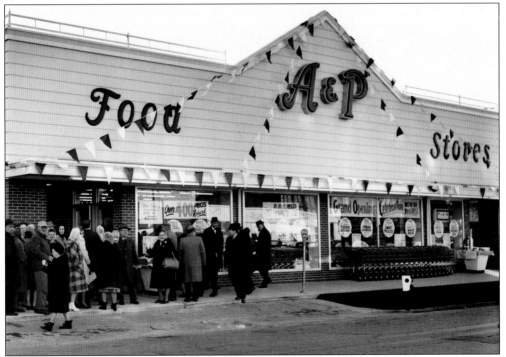

Eager shoppers lined up for sales at the opening of the A&P Store at 320 North Fifth Street. The new A&P stores that opened in the 1960s and 1970s were advertised as discount groceries. To deflect the rapid inflation of food prices, A&P and others introduced off-brand food products that were sold in black-and-white containers at reduced prices. Unfortunately, company cutbacks caused the North Fifth Street store to close in 1975.

The Raynor Hotel Company built the Holiday Inn East in an undeveloped area on Highway 66. The hotel started with 121 rooms in 1963, and through a number of expansions over the next 20 years, it became one of the largest in the city. A major expansion in 1970 in the form of a four-story high-rise added 142 rooms, including two penthouses, along with a 16-stool fast-service coffee shop, a second dining room, and a swimming pool. When the pool was enclosed in 1977, the hotel had one of the biggest Holidomes in the country at 28,000 square feet. Raynor bought the first Holiday Inn in 1963 and changed its name to Holiday Inn South (below).

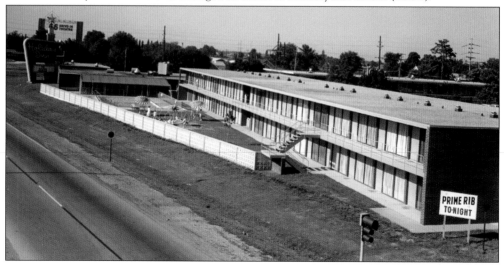

Springfield's oldest hotel, the St. Nicholas, which opened in 1856, had a long political history as the unofficial Democratic Party headquarters. Two unsuccessful attempts were made to revive the business in the 1970s, but the end came in 1977. It was commented that the $800,000 found in Secretary of State Paul Powell's room was enough to have brought the hotel out of debt. The structure located at Fourth and Jefferson Streets later became apartments.

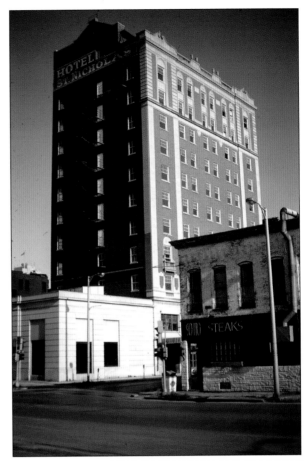

The owner of the Mansion View Motel cited the increase in tourism and conventions as the reason for building more rooms in 1961. The motel's location across from the Executive Mansion on the Fourth Street side and its proximity to the state capitol building appealed to legislators looking for a convenient place to stay. Local clubs and organizations made the attached restaurant their headquarters for weekly or monthly breakfast, luncheon, or dinner meetings.

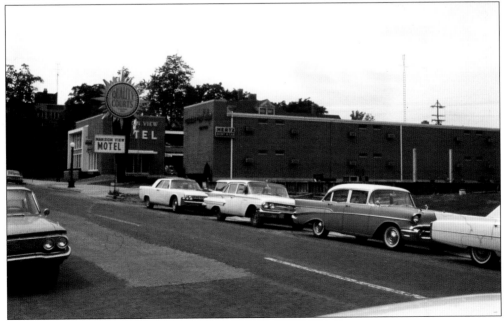

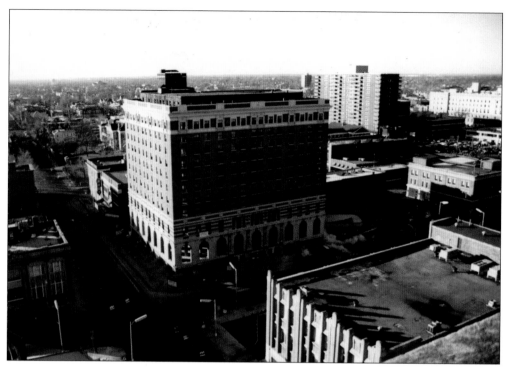

In what had to be one of the most memorable events of the year, if not the decade, the demolition of the Abraham Lincoln Hotel in 1978 was considered to be a spectacular feat. The hotel, which opened in 1925, had closed in 1964 because of failing business. Several attempts were made to reuse the building as commercial office space or residential housing prior to its destruction.

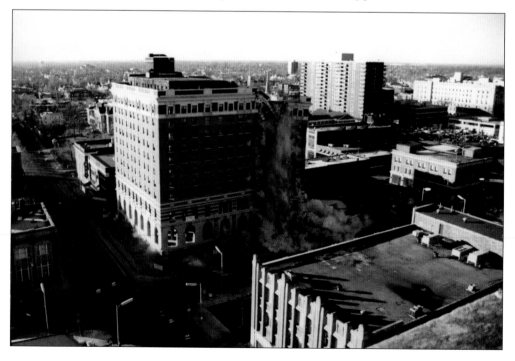

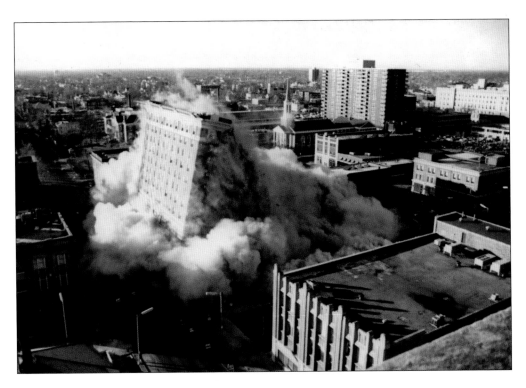

State officials finally found a purpose for the hotel site but not the hotel itself. The block on which part of the hotel stood was chosen as the site for a proposed courts complex that would house the Fourth Appellate Court and the Sangamon County Circuit Court.

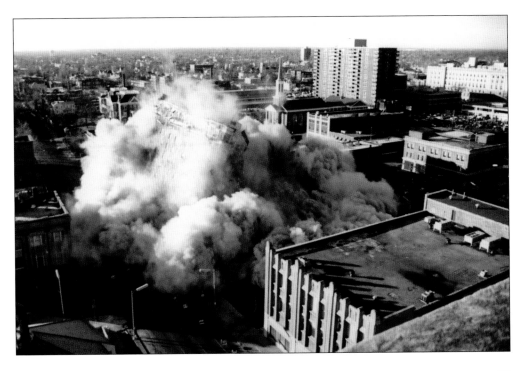

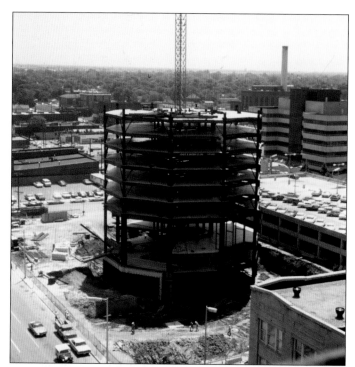

The "big three" downtown hotels—the Abraham Lincoln, the Leland, and the St. Nicholas—were closed or financially troubled when construction of the Forum 30 began. The owners hoped to compete with the new downtown motels and take advantage of the proposed civic center. The 30-floor tower was a definite departure from the previous architecture of Springfield. At 352 feet, it became the tallest commercial structure in the city.

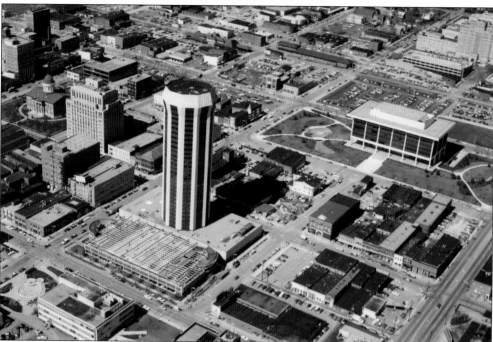

This 1974 photograph provides a glimpse of the central area of downtown Springfield amid an era of great change. The municipal and county buildings with the Eighth Street Mall are complete, and the Forum 30 Ramada is ready to open its hotel rooms. The Prairie Capital Convention Center is still in the planning stage. The ground is ready for the new police department annex on Jefferson Street.

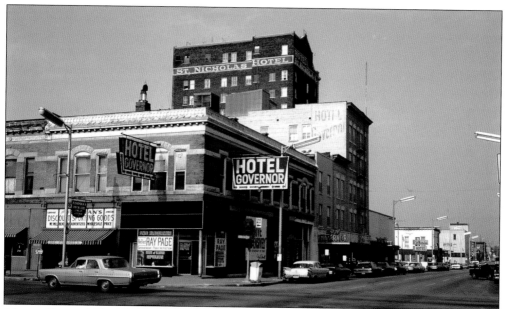

Johnny Connor's Empire Hotel was purchased, totally refurbished inside and out, and renamed the Hotel Governor, all before serving guests at the start of the 1960s. With a location in the center of the block on Jefferson Street between Fourth and Fifth Streets, the hotel's owners were optimistic about downtown Springfield. On the corner drugstore building seen in this 1970 photograph are campaign ads for former high school basketball coach Ray Page.

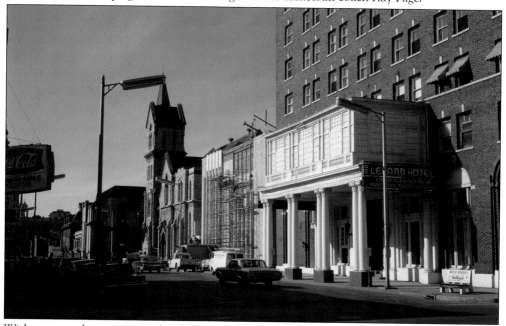

With a new parking ramp nearby, the Leland Hotel, once Springfield's finest, changed its name to the Leland Motor Hotel in 1965 to stay competitive. Despite new owners in 1969 and a barbecue and ball held as a fundraiser to bridge the gap in funding, the hotel closed in October 1970. Shown here on Capitol Avenue near the First Methodist Church, the hotel was used by Sangamon State University for a while, then as offices.

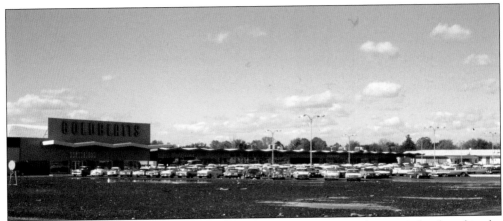

The shopping center concept was well under way with at least six such centers developed in the 1960s. One of the largest was the Town & Country Shopping Center at MacArthur Boulevard and Outer Park Drive. It was strategically located near the fastest-growing area of Springfield. The Goldblatt's department store anchored the center, along with Walgreen's drugstore and National Foods, which were part of the mix that offered new employment opportunities.

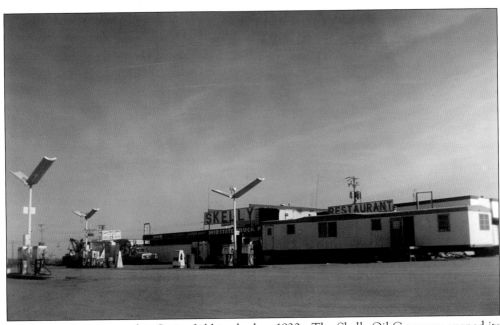

Truck stops first appeared in Springfield in the late 1930s. The Skelly Oil Company opened its Midstate Truck Stop at the intersection of Camp Butler Road and US Highway 54 in the late 1960s. The site was a good choice considering its location near the new Interstate 55 and the Interstate Industrial Park.

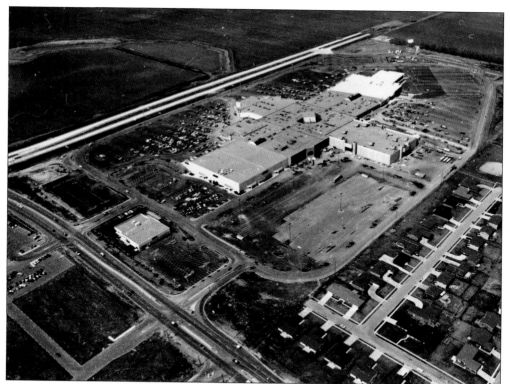

One of the biggest commercial developments of its time, the White Oaks Mall was originally called Westroads Mall when the shopping center was first announced in 1971. This aerial view shows that the mall was literally on the edge of the city. The incomplete road to the left of the mall is now Veterans Parkway.

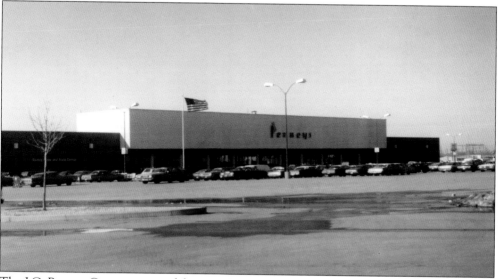

The J.C. Penney Company moved from its downtown location to 1201 South Dirksen Parkway in early 1971. The new department store was 10 times as big as the downtown store, which had been there since 1928. A grocery and automobile service station were two new features in addition to the usual departments.

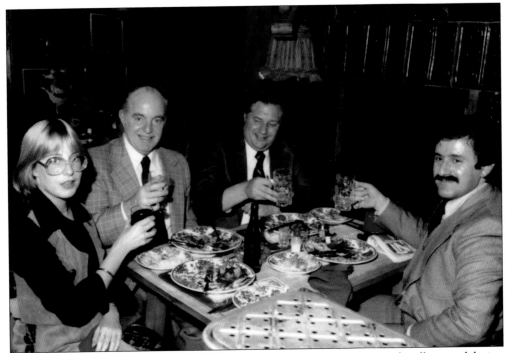

Stevie's Latin Village, owned by Steve and Alma Crifasi, was one of the many locally owned dining establishments that dominated the restaurant scene before national chains appeared. Despite its popularity during the 1950s and 1960s, the eatery had to be sold at a public foreclosure auction in 1970. Joe Trello, operator of Papa Joe's restaurants, briefly reopened the former restaurant and nightclub as the Latin Village in 1975. The building became a Chinese restaurant in 1976.

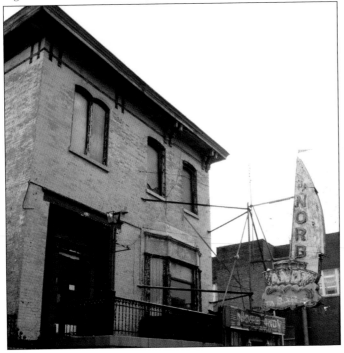

The peeling 1937 sign outside Norb Andy's Tabarin reflects its many years of welcoming politicians, lobbyists, members of the press, lawyers, and others. Too crowded for backroom deals, Norb's offered menu items unique to Springfield, such as the horseshoe sandwich and "chilli" (spelled with two Ls), along with some good jazz and cocktails. Aware that parts of the building had beginnings in the late 1830s as a home, preservationists were interested in the vacant areas.

Shakey's Pizza Parlor and Ye Public House opened at its first location, 2660 South Fifth Street, in May 1966. The new pizza franchise featured an English pub atmosphere that was supplemented by live banjo music and honky-tonk piano music. The restaurant's name was changed in 1980 when its owner dropped the Shakey's franchise.

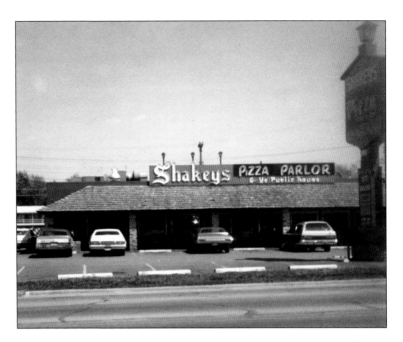

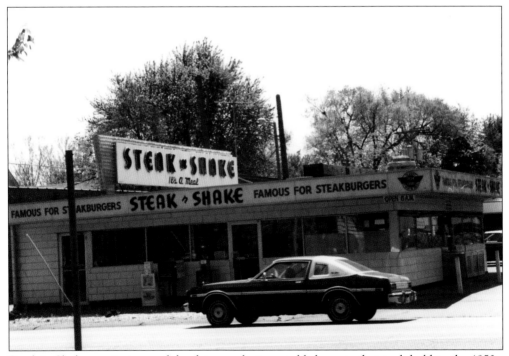

Steak 'n Shake was just one of the drive-up dining establishments that took hold in the 1950s. The restaurant's greatest appeal was to teenagers with cars. The Steak 'n Shake at 710 South Grand still had carhop service with real plates and glasses into the 1980s. The black-and-white decor was very recognizable in the Midwest, as were its steakburgers (versus hamburgers) and hand-dipped milk shakes.

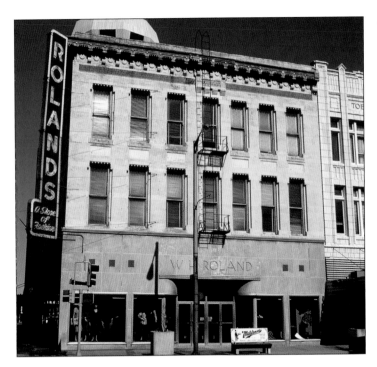

The major department stores were not exempt from the changes taking place downtown. Roland's, Myers Brothers, and Bressmer's were each bought out by larger groups. Herndon's was the only store to remain locally owned and, with Roland's, to retain its name. Each either expanded with a second store or moved to the suburban shopping centers. Myers Brothers became Bergner's, and Bressmer's became Stix, Baer & Fuller, and later Kohl's.

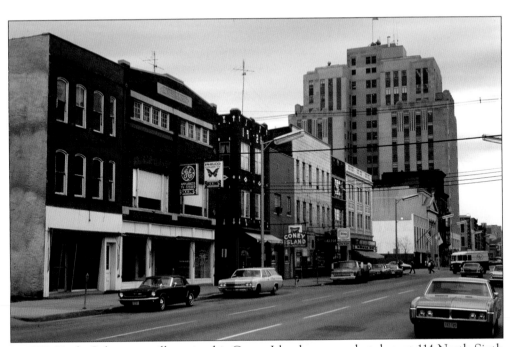

In 1970, Toula Gekus was still serving his Coney Island sauce on hot dogs at 114 North Sixth Street. The once popular appliance store, Sikkings, sits empty, having been purchased by the city for use as a parking lot. Opened in 1919, the Coney Island was the second-oldest restaurant downtown, second only to Maldaner's, which opened in 1884. Eventually, the Abraham Lincoln Presidential Library took over this entire half block.

Five

CIVIC

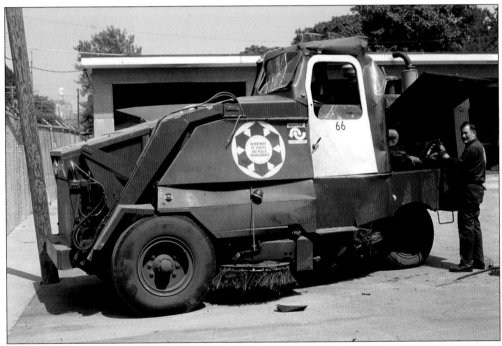

In the Western movies, it is usually the sheriff who cleans up the town, but in modern times, the street sweeper has taken over that task. One of the earliest street sweepers used by the city of Springfield was purchased for $388 in 1884. This more modern version looks a little worse for the wear. The condition and maintenance of the street department's equipment was cause for much criticism in the 1960s.

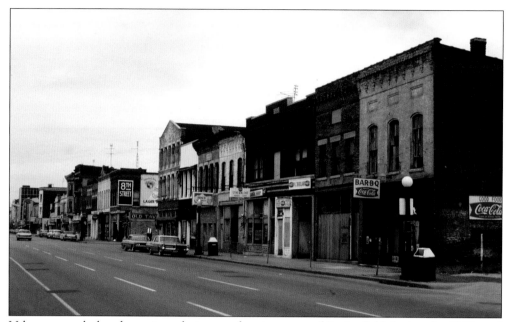

Urban renewal played a major role in transforming parts of Springfield during the 1960s and 1970s. In 1962, a plan was conceived to purchase a tract of land in downtown Springfield, tear down the dilapidated buildings, and then sell the sites to private interests for retail stores and other commercial uses. The tract selected for this project was a four-block area between Seventh, Ninth, Madison, and Washington Streets. The buildings shown here along Washington Street are just some of the 57 that were purchased and demolished for the project. Demolition of the properties began in June 1966. Planners hoped for a motel/hotel to be built on one of the sites and a shopping center to occupy another part.

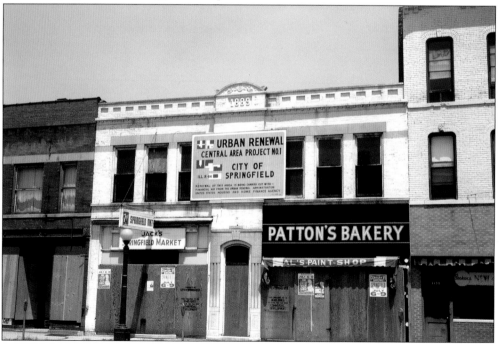

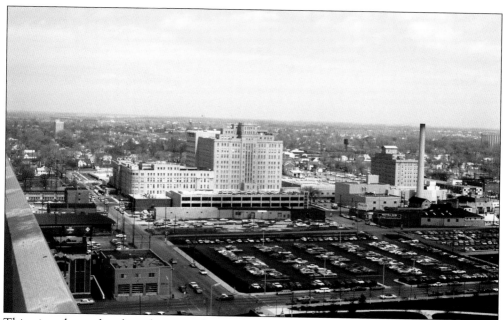

This view shows the cleared area in the northeast section of downtown Springfield. The city solicited bids for development of the tract but received only one from Horace Mann Educators Corporation. While the city reviewed the bid proposal, the site was used as temporary parking space. In June 1968, a contract was signed in which the land was sold to Horace Mann to build an office building and develop a retail shopping area.

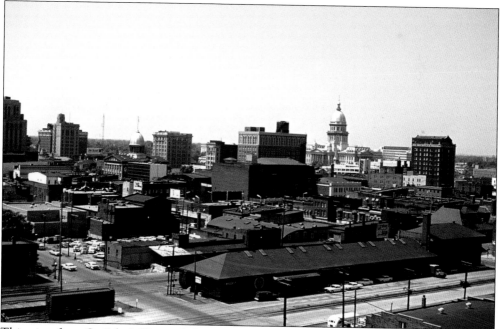

This view from St. John's Hospital shows just how much downtown Springfield has changed since the 1970s. In the foreground is the Madison Street railroad corridor, with a freight depot and boxcars on the side tracks. The two blocks just beyond the depot are now the sites of the Abraham Lincoln Presidential Museum and Union Square Park.

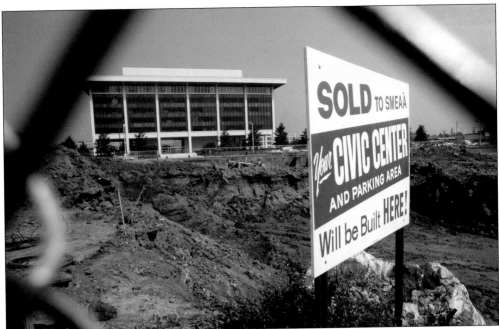

The desirability of a civic center was discussed even before World War II. A local committee formed in 1963 and was formally organized in 1965 as the Springfield Metropolitan, Exposition, and Auditorium Authority. Its goal was to boost Springfield's economy and promote trade downtown with the building of a convention center. The newly constructed Horace Mann building is seen in the background of this 1974 photograph.

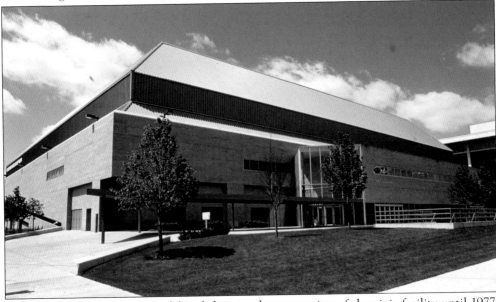

Location and financing issues delayed the actual construction of the civic facility until 1977. Mayor Michael J. Houston cut the ribbon for the Prairie Capital Convention Center on November 3, 1979, opening the 44,000-square-foot exhibit space for conventions, concerts, graduations, sporting events, and the like. Comedian/entertainer Bob Hope and country singer Margo Smith were the first headliners to perform at the venue.

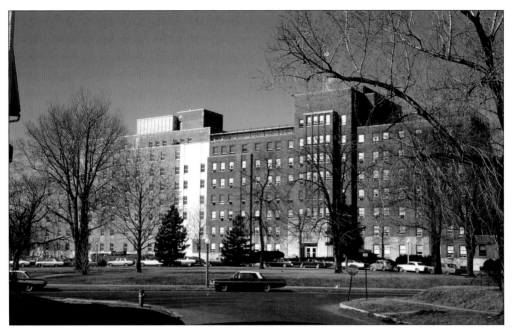

The health care industry in Springfield was evolving during the 1960s and 1970s. Memorial Hospital completed several building additions as it dealt with overcrowding. Its affiliation with the Southern Illinois University School of Medicine caused the name to be changed to Memorial Medical Center in 1974. Another major decision was the closure of the hospital's nursing school in 1975.

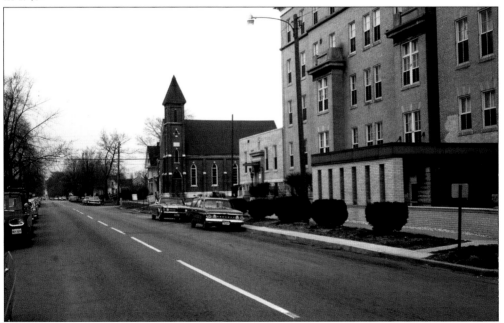

In 1963, St. John's Hospital sought the assistance of the city with its plans to expand to the north of its existing buildings. The hospital embarked on its own urban renewal project, which included a two-block area bounded by Seventh, Ninth, Reynolds, and Carpenter Streets. The Fourth Presbyterian Church, shown here, was one of the buildings in the area that was torn down.

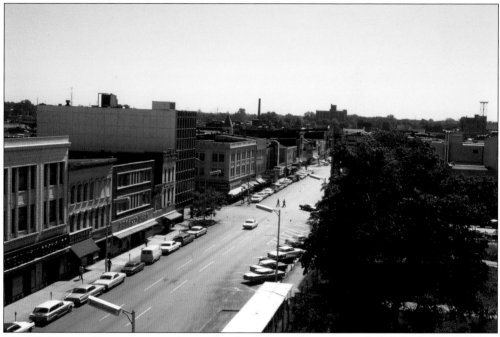

The Washington Street shops on the north side of the public square included the Springfield Dry Goods Store and Robert's Brothers, among others. A changing demand for fabric, along with other economic conditions, caused the dry goods store to close in 1964 after being on the square since 1927. The resilient Robert's Brothers suffered a disastrous fire in 1974 but rebuilt and reopened in 1976. It also expanded into the suburban shopping centers.

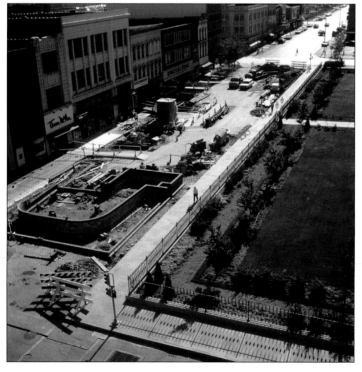

A proposed beautification project that would close Washington and Adams Streets for a plaza area was met with opposition, especially in regard to traffic concerns. However, there was a strong sentiment that the downtown would benefit from "people space" that was inviting for tourists and shoppers. Such an area would also enhance the surroundings of the newly restored Old State Capitol. The streets were closed in 1970.

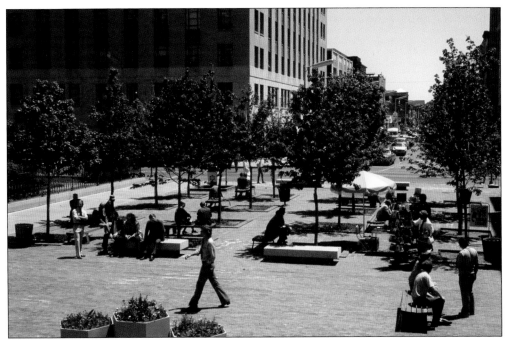

Plans for the plazas called for the planting of trees around the square, along with the installation of benches, special lighting, and pools with fountains. By 1974, work on the plazas had been completed, and people, like those shown here on the South Plaza, could enjoy them. With the observation deck and adjacent businesses, the South Plaza proved more popular than its northern counterpart.

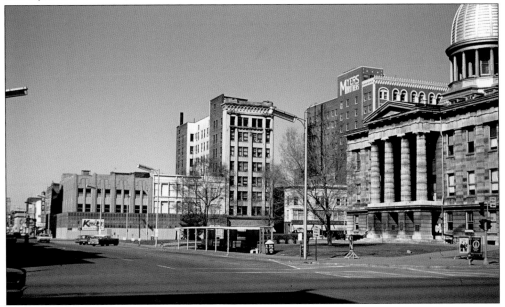

The S.S. Kresge store at 419 East Adams Street began as a five-and-ten store in 1913. In 1929, it became Dollar Kresge, and in 1964, the downtown site was expanded using the new retail model, the Kmart discount store. As a full department store, it sold items such as televisions, furniture, and power tools. A single checkout area near the entrance was also part of the new discount shopping experience.

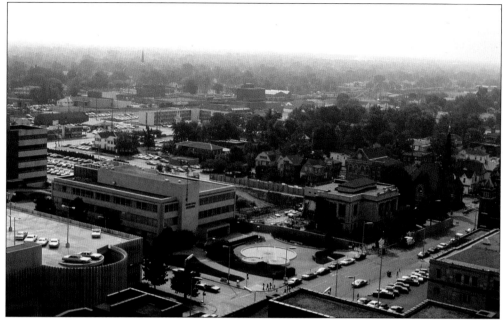

The southeast corner of Seventh and Monroe Streets has been the site of municipal government since the first city hall was built there in 1894. Before this building, the City of Springfield leased office space and council meeting rooms. By 1956, the old city hall, shown below, had become a crumbling fire hazard that violated many of the city's own building and safety codes. Costs for repairing and renovating the building proved to be excessive. In 1960, the new municipal center was constructed just east of the old city hall, which was demolished in May 1961. The view above shows the new municipal building, along with the Lincoln Library and the Sangamon County Building.

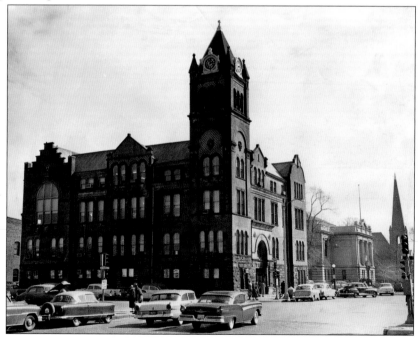

The new Sangamon County Building was dedicated on May 1, 1966, with Gov. Otto Kerner giving the principal address. The H-shaped building was constructed on the northern half of the 800 block of East Monroe Street by the Springfield Public Building Commission, which also owned and operated it during an initial 20-year lease with Sangamon County. Financing for the construction came from the sale of the Old State Capitol building to the State of Illinois.

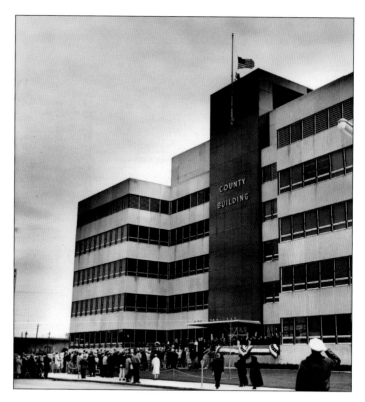

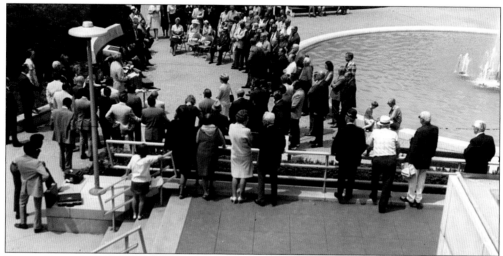

Former Springfield mayor Nelson Howarth was honored with a plaza in his name for his civic work in such projects as the construction of the Springfield Municipal Building and the Sangamon County Building. Located on the site of the old city hall, Howarth Plaza was dedicated on May 25, 1972. A group of Howarth's family and friends are shown at the dedication ceremony.

A project to remodel the Masonic Temple at 420 South Sixth Street and build a Scottish Rite Cathedral was announced in 1960. A new structure was added to the north side of the present temple, which was completely renovated. One of the main features of the new building was an auditorium with a seating capacity of 700 people. The new temple, now doubled in size, was dedicated on April 15, 1962.

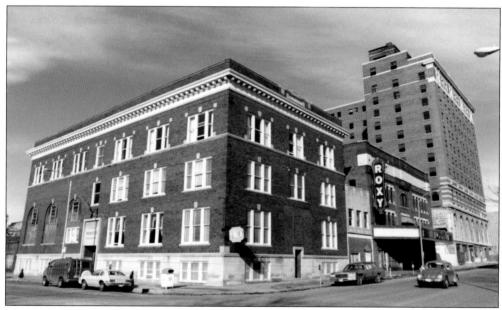

The YWCA and Roxy Theater were two of the buildings that the State of Illinois sought to have demolished to make way for a proposed courts complex that would occupy the entire block. The Roxy was demolished in 1979. YWCA officials fought the state's condemnation suit for several years before being allowed to remain at their location.

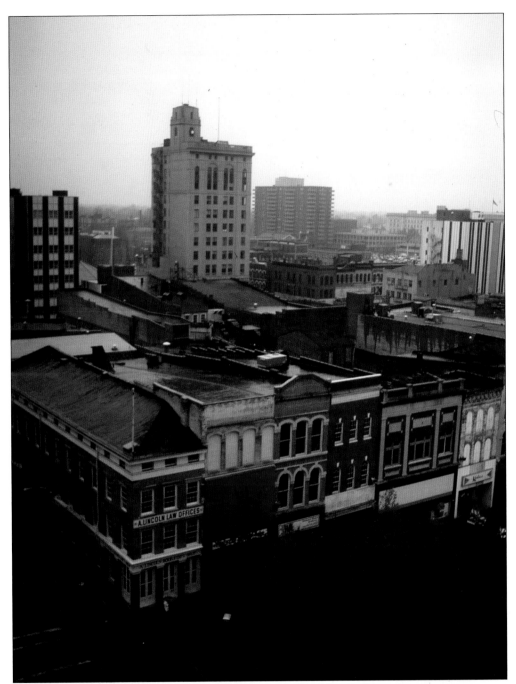

It is hard to recognize what is now called the Lincoln-Herndon Building from the picture seen on page 10. The gray paint was sandblasted away, revealing the soft brick color of the local clay. Visitors now have an idea of what a new building might have looked like in Lincoln's time. Known as the Tinsley Building before restoration, it was built by merchant Seth Tinsley in 1840. It continued as prime retail and office space on the public square until its use as a privately owned historic site. In 1985, the State of Illinois acquired the site to continue telling the stories it played in Lincoln's life.

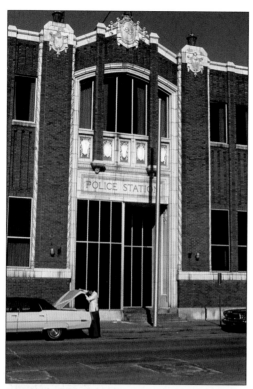

Noted Springfield architect Murray S. Hanes designed the 1928 police station's exterior so it had the "air of a public office building" and not that of a jail. The building served until 1996. When it was proposed that the whole block on Jefferson Street between Sixth and Seventh Streets could be used for the new Lincoln Presidential Museum, preservationists unsuccessfully tried to save at least the building's facade.

New city functions required more office space. A two-story office and garage building with a parking deck on top was built next to the police station on Jefferson Street in 1975. The new Human Relations Commission and Fair Housing Board, previously in rented space, received offices, along with some police divisions. The garages were for the police, the rescue squad, and civil defense department.

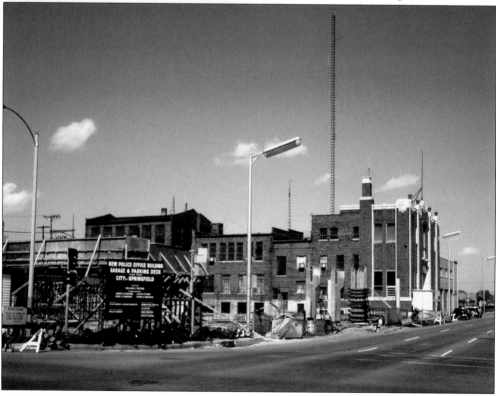

Seemingly climbing to nowhere, these Springfield firemen are training on the fire department's 100-foot aerial ladder truck at the department's training facility on Stevenson Avenue. A training tower was also located at the facility to be used in controlled fire exercises. The department was able to purchase a new ladder truck in 1971.

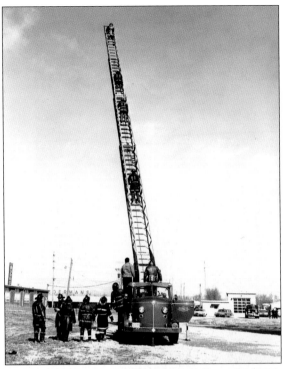

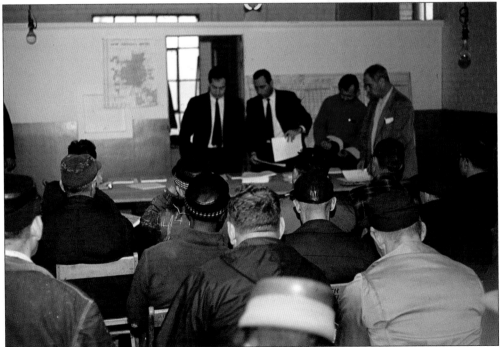

Newly elected commissioner of streets and public improvements William Cellini reorganized the department into 13 work crews under a definite chain of command. This department was responsible for such things as sidewalk repair and cleaning, snow and ice removal, and sewer maintenance. Cellini is shown here having a meeting with some of the employees under his supervision.

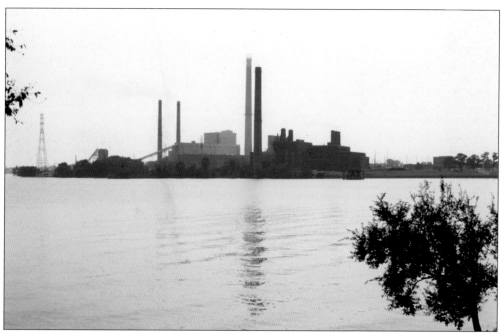

Lake Springfield has served a number of roles during its existence. Besides being the main source for drinking water and the hydroelectric power plants of Springfield, the lake had more than 500 acres of land dedicated to parks and a golf course in the 1960s. Droughts in the mid-1950s and 1964 concerned utilities commissioner John Hunter enough to recommend building a second lake a half mile east of the existing lake.

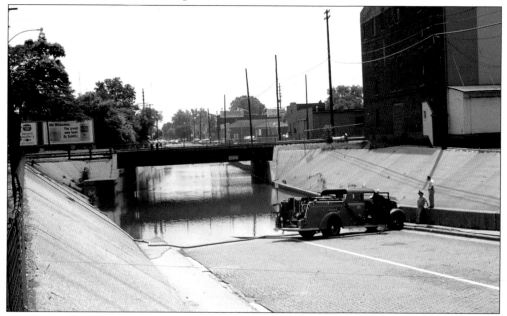

Flood control was an ever-present concern, especially for the subways that ran under the railroads crossing through Springfield. The city had to install new pumps in 1962 to replace the defective ones that were unable to keep up with the rainwater at the subway at Tenth Street and South Grand Avenue.

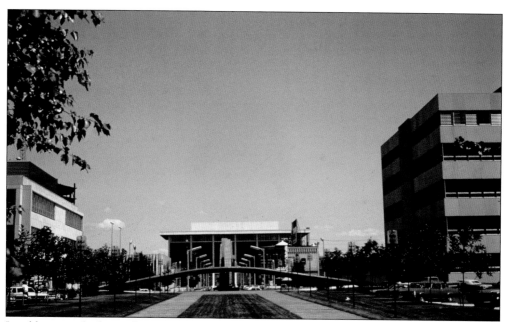

In addition to the beautification project to create plazas on the public square, there was a plan for a mall area between the municipal and county buildings. Looking north, visitors to the Lincoln Home would see a green area that architect Earl W. Henderson Jr. described as a link between "history and government and the future of the city." Eighth Street was closed between Capitol Avenue and Monroe Street, and landscaping and an elevated bridge between the two buildings were added.

Through the combined effort of individuals, organizations, the community, and the city, Springfield was able to provide an impressive list of accomplishments on its application for the All-America City Award. There was a range of projects from new schools of higher education and preservation of historic heritage to minority business and housing support. In 1970, the National Municipal League and *Look* magazine awarded Springfield the honor of All-America City.

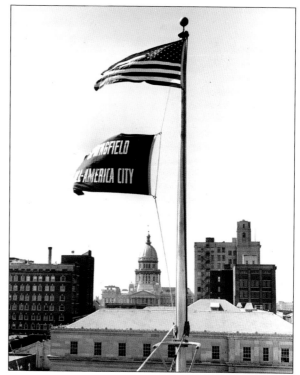

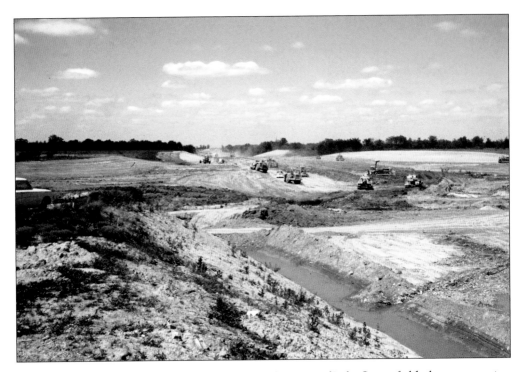

Considered to be the largest project since the development of Lake Springfield, the construction of Interstate 55 in the early 1960s was an economic boon for the city of Springfield and the surrounding area. Described in newspaper reports of the time as the "New East Bypass," the new route stretched 15 miles from the village of Sherman in the north to the Illinois National Guard Depot in the south. With an estimated cost of $22 million, the new bypass created hundreds of construction jobs. Interstate 55 opened to through traffic in November 1963.

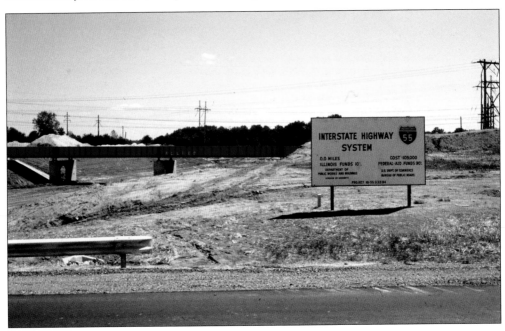

Even though the cloverleaf interchange was invented long before the interstate highway system came into existence, this useful method of moving vehicles from one freeway to another has become a familiar site along interstate highways. The interchange shown here is a partial cloverleaf pattern where Interstate 55 met with South Sixth Street.

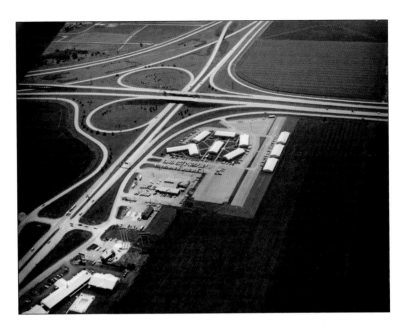

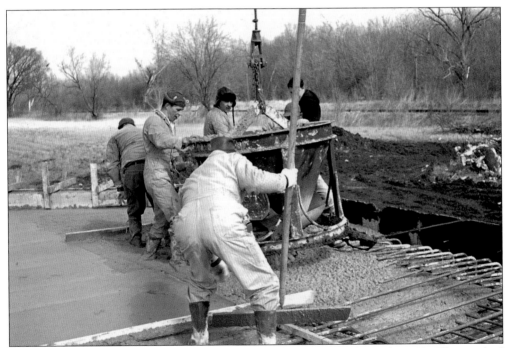

Major road improvement programs were started in Springfield in the early 1960s. The city had about 160 miles of paved roads and 90 miles of unpaved roads. The programs involved paving roads, done by street department workers like those shown here, and extensive preventive maintenance work to keep roads from deteriorating.

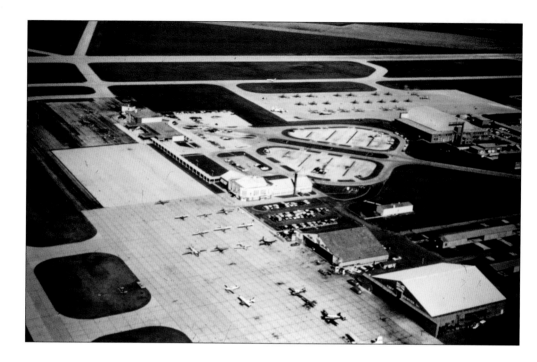

Capital Airport was a busy place during the 1960s and 1970s. In 1963, airline passenger counts exceeded 100,000 for the first time since air service was introduced in 1947. The airport had three concrete runways that stretched across a 1,300-acre site in six directions. New aircraft hangar space was also developed during this time. These hangars were leased to companies like Capitol Aviation Inc., which sold aircraft in addition to offering complete maintenance services, charter flights, and flying instruction. Capitol Aviation was sold to AiResearch Aviation Company of Los Angeles in 1976.

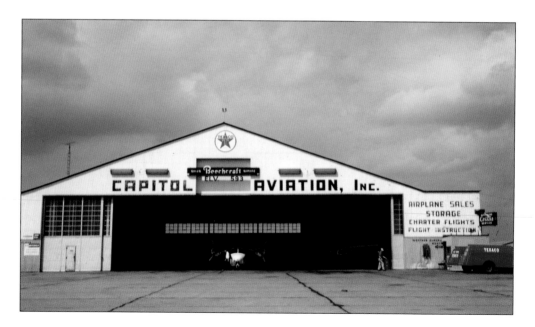

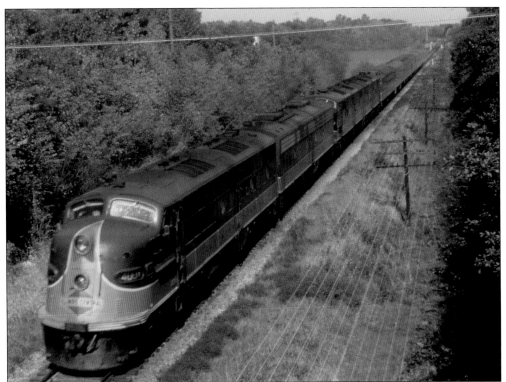

Streamlined from front to rear, the *Green Diamond* passenger train served the Illinois Central Railroad from 1936 to 1968, providing service between Chicago and St. Louis. The train stopped at Springfield's Union Station as part of the trip between the two cities. Once a common mode of transportation in Springfield, passenger train service is now limited to Amtrak. The *Green Diamond* is shown crossing Lake Springfield on its way into the city.

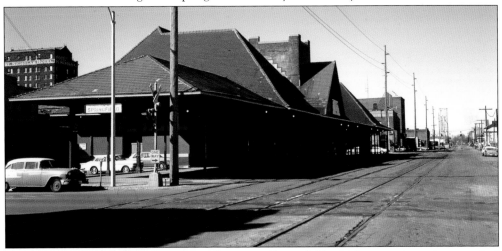

The railroad caused traffic congestion in downtown Springfield, which was an issue that stretched back to 1925, when the city's first official plan was created. In 1967, the Capital City Railroad Relocation Authority was established to create a plan to remove the railroad right-of-ways from the downtown area and consolidate them. The Madison Street tracks, shown here, were the only rails to be removed.

The St. Agnes church, rectory, and school were situated on most of the block between Capitol Avenue and Monroe Street and Spring and College Streets. With its location adjacent to the new Stratton Office Building and other state property, parking had become a problem for the parish. The Catholic diocese sold the land to the state in 1979. The parish began building a new school near Griffin High School, and the church buildings were taken down in 1984.

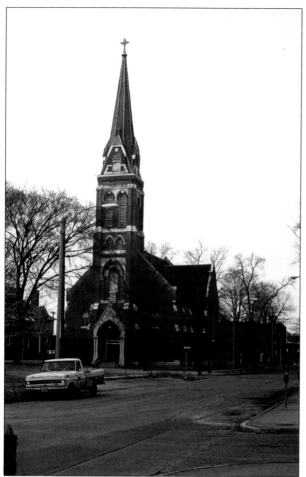

Members of the First United Methodist Church at 501 East Capitol Avenue felt staying downtown was where they could best fulfill their mission to serve the community. They built a new education center on property next to the Leland Hotel in 1968. Unexpectedly, a deteriorating condition was found in their 1884 stone church, and it was condemned. With successful fundraising, a new church was consecrated in June 1979.

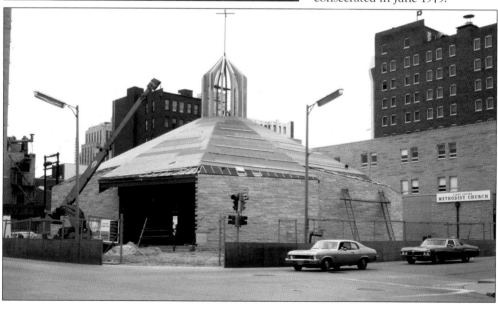

Six

EVENTS

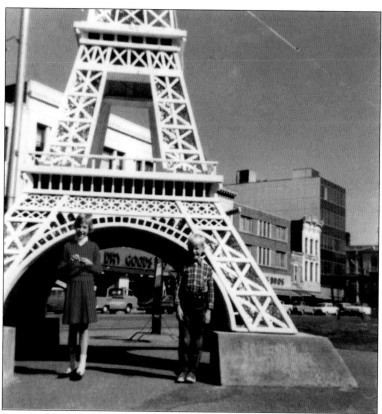

The 1964 Festival de France was an unprecedented event for downtown Springfield. Each of the four corners of the public square had either an Eiffel Tower or Arc de Triomphe. For 10 days in October, French flags flew, two *agents de police* from France patrolled the streets, and local street sweepers wore French costumes and used reed brooms. Activities were numerous, from folk dances, style shows, and bike races to sidewalk cafés and organ music. The downtown merchants, along with local organizations, provided the activities. It was all part of a French trade fair coordinated with the Springfield Central Area Development Association by the commercial council to the Consulate General of France, which invested $30,000 in the venture.

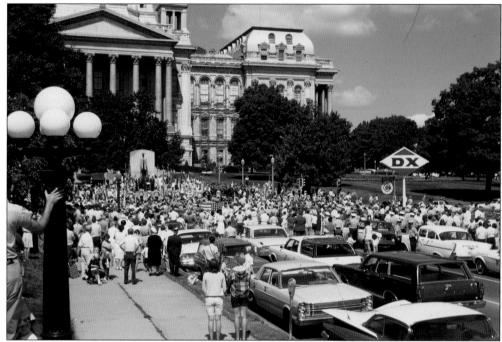

The Lincoln statue area in front of the state capitol at the intersection of Second Street and Capitol Avenue was a prime gathering place for ceremonies, speeches, rallies, and demonstrations. The Boy Scouts' pilgrimage to the Lincoln Tomb often ended there. The Memorial Day and Independence Day Loyalty Parades sponsored by the Inter-Veterans Council in 1967 also concluded at the site.

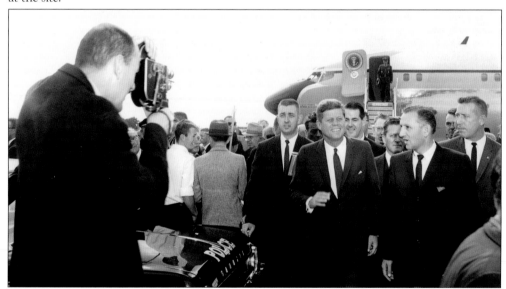

Behind Pres. John F. Kennedy's smile for the welcoming crowd in October 1962 was serious concern. He was on a campaign tour to support Democrat candidates and spoke to an enthusiastic crowd at the fairgrounds' Coliseum. The rest of his tour was canceled abruptly. Soon it was learned that he was keeping up a business-as-usual facade until confirmation came that the Soviet Union had missiles in Cuba aimed at the United States.

It had been 100 years since Springfield witnessed the 1865 funeral and burial services for Pres. Abraham Lincoln. In May 1965, Lincoln's former home was draped, as photographs from the historic event illustrated. Springfieldians memorialized the proceedings with four days of banquets, receptions, speeches, plays, and concerts.

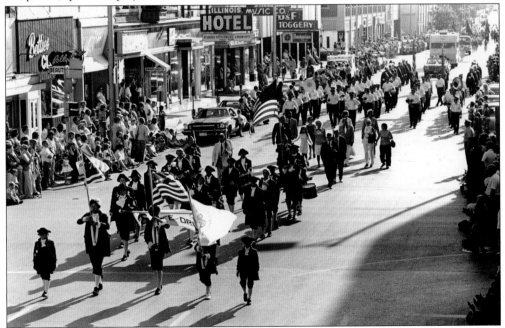

In Springfield, the country's 200th birthday was celebrated with more than a patriotic parade. Planning had begun years ahead, and the yearlong celebration kicked off on July 4, 1975. The following year, on July 4, 1976, all sides of the public square had activities, including Colonial craft demonstrations, a puppet show on women in history, choral groups performing patriotic songs, an ecumenical religious service, and the Sound and Light Show at the end of the evening.

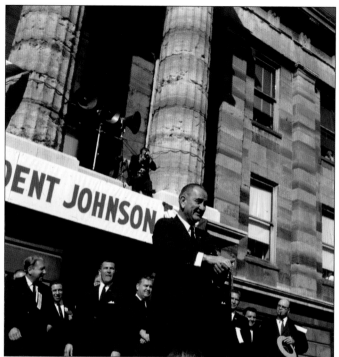

Presidential candidate Lyndon B. Johnson and his opponent Sen. Barry Goldwater both made whistle stops in Illinois in October 1864. Johnson's 90-minute visit in Springfield allowed time to say hello to the Lanphier High School band and students gathered at Fifth Street and North Grand Avenue, give a major campaign speech from the courthouse steps (Old State Capitol), and pay respects to Abraham Lincoln by laying a wreath at his tomb.

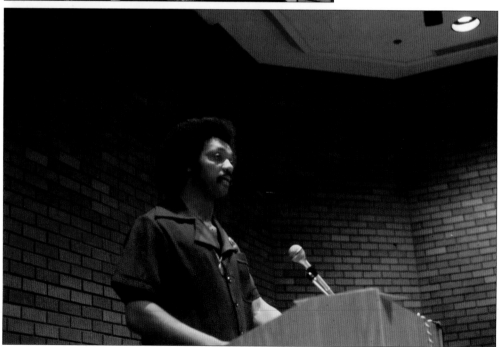

As part of a series of programs and activities for the dedication of the new Lincoln Library building, held in combination with the National Library Week of April 17–23, 1977, the Rev. Jesse Jackson spoke to an overflow crowd. The founder of Operation PUSH (People United to Save Humanity) spoke on "Libraries, Literacy and Liberty," exhorting the audience to not waste their minds and to work to prevent this waste in our society.

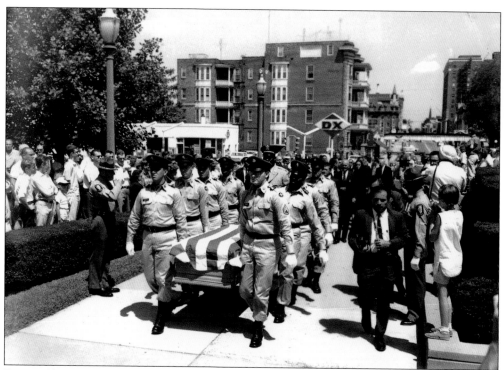

Former Illinois governor, two-time presidential candidate, and chief US ambassador to the United Nations Adlai Stevenson died suddenly while in London on July 14, 1965. After a memorial service in Washington, DC, his remains were brought to Springfield to lie in state in the capitol rotunda, the casket resting on the same bier as Abraham Lincoln's. Thousands paid their respects before Stevenson's burial at Evergreen Cemetery in Bloomington, Illinois.

On October 8, 1965, Dr. Martin Luther King was not timid in reminding his audience that, some 30 years ago, the labor movement was strong in seeking equal rights for the underprivileged and oppressed but was "timid" when it came to joining with the civil rights movement working for those same rights. The Nobel Peace Prize winner spoke at the Illinois AFL-CIO convention held at the armory.

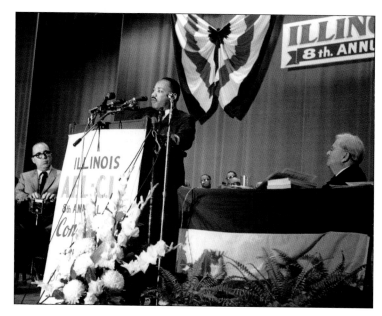

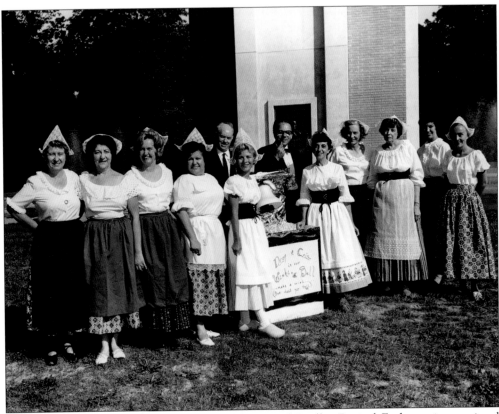

The dedication of the carillon in 1962 initiated the annual Carillon Festival. Each year, international guest carillonneurs are invited to give concerts at the event. This group of ladies in their Dutch-inspired costumes formed in 1965, calling themselves the Carillon Belles. They are pictured here with Springfield's carillonneur Raymond A. Keldermans (left) and Leen 't Hart of the Netherlands.

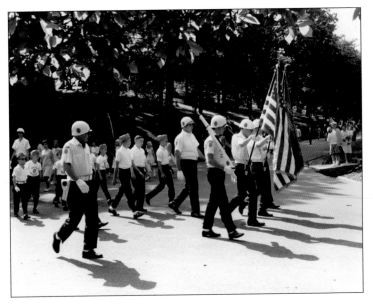

A parade from the downtown area to Oak Ridge was part of the annual Memorial Day activities going back to early observances. Veterans groups like the American Legion would have ceremonies of their own and then would participate in the parade. This photograph shows members of the Legion in the parade at Oak Ridge, followed by the group's junior auxiliary, the Sons of the American Legion.

It seemed as though the pond was frozen for ice-skating all winter long during the 1960s and 1970s. With 30 days of temperatures at or below 0 degrees in 1963, it was too cold for some water pipes about town and almost too cold for skating. In 1977, the month of January broke the record with an average temperature of 10.3 degrees. The coldest day was January 17, when the temperature was −21 degrees.

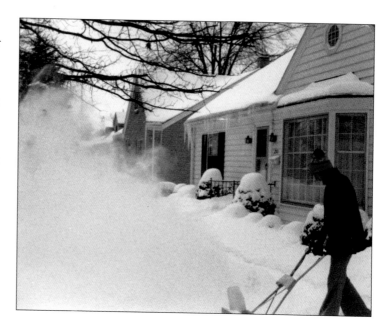

Snowfall in the winter of 1977–1978 broke the records, with a total of 53.2 inches by March 17. Combined with cold temperatures, there were five weeks in which the ground was covered white. The record for the most snow in 24 hours was a tie between February 24, 1965, and March 7, 1978, both with a recorded 8.20 inches in addition to other snow already on the ground, and a record total of 11 inches over a weekend in January 1964.

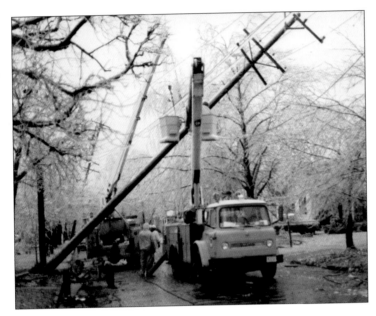

Mild temperatures were forecast for Good Friday on March 24, 1978, but what occurred has been called the worst weather disaster in central Illinois. Temperatures hovered around freezing as drizzle and rainfall aided by winds up to 50 miles per hour formed thick coverings of ice. There was an eerie beauty to the ice crystals despite their destruction, causing many branches and power lines to come crashing to the ground.

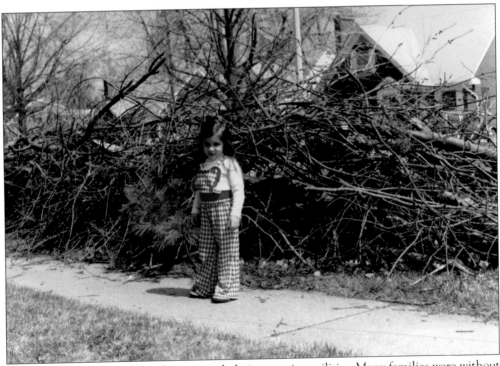

The spring sun melted the ice but was no help in restoring utilities. Many families were without power for nearly a week and much longer in rural areas. There was hardly a tree in town that did not suffer damage, and the streets were lined with piles of branches for weeks.

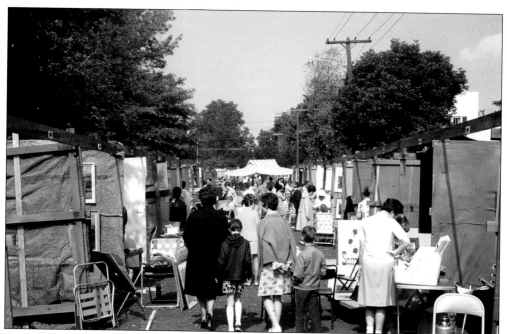

From 1966 to 1971, the name of the Old Capitol Art Fair remained the same despite a change in location. Due to restoration work on the Old Capitol, booths were set up on Eighth Street in the Lincoln Home Area. The annual event, which began in 1962, featured art in a variety of mediums from throughout the Midwest. In 1968, applications from artists were so numerous that the fair became an invitational event.

A pageantry of flags accompanied by marching bands made the annual Boy Scouts' pilgrimage to the Lincoln Tomb an exhilarating, patriotic experience. When the pilgrimage began in 1946, Scouts assembled on the Old Capitol grounds and marched to the tomb. With the Old Capitol under restoration in 1966, ceremonies began at the tomb, and Scouts, both boys and girls, marched to the Abraham Lincoln statue on the present capitol grounds.

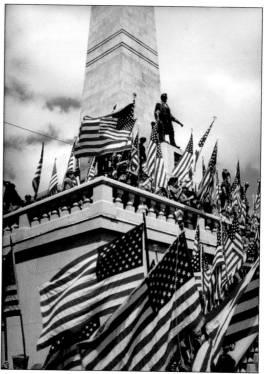

Discover Thousands of Local History Books Featuring Millions of Vintage Images

Arcadia Publishing, the leading local history publisher in the United States, is committed to making history accessible and meaningful through publishing books that celebrate and preserve the heritage of America's people and places.

Find more books like this at
www.arcadiapublishing.com

Search for your hometown history, your old stomping grounds, and even your favorite sports team.